...ner Photographs, 1966–1969

Yale University Press Harvard University Art Museums
New Haven and London Cambridge

Scott Rothkopf

Mel Bochner Photographs

1966–1969

with an essay
by Elisabeth Sussman

This catalogue was published in conjunction with
the exhibition *Mel Bochner Photographs,
1966–1969*, organized by the Harvard University
Art Museums,Cambridge, Massachusetts.

Harvard University Art Museums, Cambridge
March 16–June 16, 2002

Carnegie Museum of Art, Pittsburgh
October 2002–January 2003

Support for the exhibition was provided by
Suzanne F. Cohen, Deborah and Martin Hale, Keith
and Katherine Sachs, George David, Constance R.
Caplan, Arthur M. Cohen, The Fifth Floor
Foundation, Mr. and Mrs. D. Ronald Daniel, and
the John M. Rosenfield Teaching Exhibition Fund.

Published with assistance from The Mary Cody
Tew Memorial Fund.

Designed by Daphne Geismar
Set in Frutiger type by Amy Storm
Printed in Singapore by C S Graphics

Library of Congress Cataloging-in-Publication Data
Rothkopf, Scott, 1976–
Mel Bochner Photographs, 1966–1969/Scott
Rothkopf; with an essay by Elisabeth Sussman.
 p. cm.
ISBN 0-300-09348-9 (paperback: alk. paper)
1. Photography, Artistic—Exhibitions. 2. Bochner,
Mel, 1940—Exhibitions. I. Bochner, Mel, 1940–
II. Title.
TR647.R68 2002
779'.092—dc21 2001006562

A catalogue record for this book is available from
the British Library.

The paper in this book meets the guidelines for
permanence and durability of the Committee
on Production Guidelines for Book Longevity of
the Council on Library Resources.

10 9 8 7 6 5 4 3 2 1

Contents

Director's Foreword

Nothing is more central to our mission as teaching and research museums than to respond with encouragement and enthusiasm to students' proposals for exhibitions and publication projects. When Scott Rothkopf came to us more than three years ago with the proposal to organize an exhibition of Mel Bochner's photographs, we jumped at the chance. At the time, Scott was a Harvard College senior with a most impressive academic record and with a precocious interest in, and knowledge of, contemporary art. We were able to offer Scott a postgraduate year to organize the exhibition and to research its accompanying catalogue. After that year, Scott returned to Harvard to pursue his Ph.D. degree and complete work on this project.

We are enormously grateful to Scott for his dedication to this project. He quickly saw in Mel Bochner's pioneering photographs of the 1960s evidence of the role photography may have played in the formation of Conceptual art itself, rather than seeing it simply as a way to document conceptual activities, as so many others have proposed. This insight, and the evidence Scott marshals in his essay, make this book a crucial addition to the bibliography on this important aspect of contemporary art.

As always, and with characteristic intelligence and enthusiasm, Wynn Kramarsky lent his support to the exhibition from the beginning and we are deeply in his debt. For their generous support of this project, and for their belief in our teaching mission, we are also sincerely grateful to Suzanne F. Cohen, Deborah and Martin Hale, Keith and Katherine Sachs, George David, Constance R. Caplan, Arthur M. Cohen, Mr. and Mrs. D. Ronald Daniel, Barbara Krakow Gallery, The Fifth Floor Foundation, and the John M. Rosenfield Teaching Exhibition Fund.

James Cuno
Elizabeth and John Moors Cabot Director

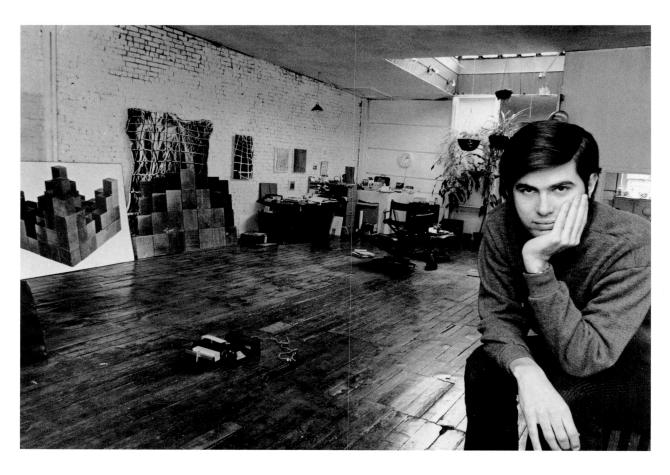

Mel Bochner in his studio, 1968

Preface:
Toward a "Conceptual"
Framework

This catalogue and the exhibition it accompanies provide the first comprehensive assessment of Mel Bochner's photography of the 1960s. Although Bochner's drawings and installations have been widely acknowledged as seminal works in the history of Conceptual art, the full extent of his photographic practice has remained virtually unknown.[1] This neglect arose in part because Bochner exhibited only a small number of his photographs at the time of their creation, and he abandoned the medium before beginning to show his work more broadly.[2] Furthermore, Bochner's photography has remained largely absent from later critical writing on the medium's place within Conceptual art, because that discourse has focused on concerns not central to his photographs. However, a renewed interest in the history of photoconceptualism and developments in contemporary art, such as the proliferation of hybrid media, as well as "constructed" and digitally manipulated photography, provide fresh impetus to reassess earlier artistic forays into related terrain. This catalogue then aims not only to recuperate a previously overlooked body of work, but also to revisit photography's role in the birth of Conceptual art.

Conceptual art is generally understood to be a late 1960s development that sought to shift attention from the physical object to the ideas or theory behind artistic practice, and photography has rightly been conferred a prominent place in that process. According to many critics and scholars, photography's inherent multiplicity, its supposed neutrality, and its modest scale and limited market made it an expedient solution to this problem of challenging or "dematerializing" the singular, rarified object.[3] In addition, photography's "documentary" capabilities allowed artists to record remote and ephemeral activities, which were themselves understood as questioning the status of the physically encumbered artwork.[4] These characterizations of the medium have ably accounted for a wide variety of Conceptual practices, from Bruce Nauman's snapshots of madcap studio exercises to Dan Graham's mass deployment of his photographs in ephemeral magazine pieces.[5]

Given the medium's efficacy in performing these tasks of "documentation" and "dematerialization," photography has come to be treated as an almost

inevitable answer to Conceptualism's predetermined needs. Most accounts of the medium's emergence in the art of the late 1960s tend to overlook the profound unexpectedness of the rupture between the predominance of Minimalism's insistent physicality and photography's more immaterial illusionism.[6] Critics and historians have downplayed the very improbability of the camera's adoption, as though it were necessarily sanctioned by the shift from Minimal to Conceptual art, rather than considering how the camera may have in some cases engendered that transition. Yet, such a deterministic explanation of the medium's emergence is to a certain extent inadequate, because it presupposes that Conceptualism was somehow already wholly formed and had a job for the camera to do—rather than asking how the conditions of photography itself may have helped open up the possibility of "conceptual" activities in the first place.

Such an instrumental reading of photography may not be surprising given the linguistic model of Conceptual art prominent since the early 1970s. Benjamin Buchloh has aptly defined this linguistic emphasis as an attempt "to replace the object of spatial and perceptual experience through linguistic definition alone."[7] Evidence of such a transition might be found in Lawrence Weiner's written statements, which need not be physically executed to be considered valid or complete, and in Joseph Kosuth's late-sixties work of which he remarked, "The forms were only a device in service of the idea."[8] Given this line of reasoning, Kosuth's claim to have used photography strictly as a "*means,*" rather than "as an end in itself," would be perfectly consistent with his a priori conception of the artwork wherein the artist is said to know exactly what a work will signify before determining a sign—whether linguistic, photographic, or otherwise—which might communicate the idea most transparently.[9] In this model of Conceptual art, photography is reduced to an instrument that conveniently serves a specific function, yet does little to shape or inform the meaning of the work (or the artist's thinking), because its primary attraction is precisely its reluctance to do so.

This "pure" linguistic formulation, however, has never been the sole definition of Conceptual art. Sol LeWitt, for example, has stressed that even though "the idea or concept is the most important aspect of the work," it must still be executed and experienced perceptually by the viewer: "Once given physical reality by the artist the work is open to the perception of all, including the artist. . . . The work of art can only be perceived after it is completed."[10] So, even if LeWitt formulates his work in advance, leaving nothing to be determined on execution, he understands his works as more than perfect "illustra-

tions" of preconceived ideas, because they are eventually apprehended as physical objects open to the viewer's sensory perception.

Bochner himself has proven even more consistently concerned with the open-ended interaction between a concept and its implementation—an approach that denies the possibility of a perfectly premeditated artistic practice. It is therefore difficult to characterize his turn to photography as the inevitable tool of some entirely predetermined Conceptualism, a trend still nascent when Bochner adopted the medium in the winter of 1966. Given that early point in the development of an art that would only later come to be labeled "conceptual," it is difficult to assume that at the moment Bochner turned to the camera he already saw his project in relation to the set of theoretical positions that term would come to describe.[11] So, rather than relying on a teleological model of a Conceptualism wholly preconceived and equipped with a "plan" for photography's use, in Bochner's case it will be necessary to consider how the medium itself both allowed for and tempered the very possibility of a "conceptual" art. In my essay "'Photography Cannot Record Abstract Ideas' and Other Misunderstandings," photography will be seen as "actively" involved in the creation of Bochner's work, because the camera led him to engage concepts and explore ideas that he might not have specifically addressed without its collaboration.

Bochner did, as we will see, have a plan for photography, but luckily for him the camera didn't oblige.[12] Like his contemporaries, he turned to the medium in part to serve an idea, but unlike many of them, he soon determined that photography could communicate ideas no more transparently than sculpture, or painting—or language, for that matter. Once adopted, the camera proved incorrigible, always interjecting unforeseen distortions and anomalies of its own device. Yet rather than ignore them, Bochner chose to seize upon these gaps between the "real" world and the camera's picture of it. Ultimately, it would be within the unique discursive and physical space of photography that he would come to formulate his mode of Conceptual art, with its anxious and elegant negotiation between the linguistic and the perceptual. To assume that Bochner understood that interplay a priori, and that photography merely served as an illustrative means, would be to accept the very position he came to reject—that art could exist as an idea without any recourse to its physical support. Instead, we must consider how photography played an active role in the development of Bochner's art, not simply giving form to his ideas, but, rather, revealing visual phenomena he never thought to see.

Notes

1 Several of Bochner's photographs (generally the earlier works) have been published and exhibited over the last thirty years, but they have never been seen together in their entirety. In 1991 the David Nolan Gallery, New York, devoted an exhibition exclusively to Bochner's photography, though less than half of his photographic works were included in the show. See *Mel Bochner: Photo Pieces 1966–1967*, exh. cat. (New York: David Nolan Gallery, 1991). Richard Field also included some of Bochner's photographs in his exhibition and catalogue surveying Bochner's early work. Field's superbly researched text and lucid chronologies have served as an indispensable aid in the preparation of the present exhibition. Field's catalogue also includes an essay by Sasha Newman on Bochner's photography titled "The Photo Pieces." See Richard Field, *Mel Bochner: Thought Made Visible 1966–1973*, exh. cat. (New Haven: Yale University Art Gallery, 1995). Although it does not discuss photography at length, Brenda Richardson's exhibition catalogue surveys Bochner's work over the years during which he was engaged with the medium. See Brenda Richardson, *Mel Bochner: Number and Shape*, exh. cat. (Baltimore: The Baltimore Museum of Art, 1976). Robert Pincus-Witten's numerous discussions of Bochner's work in the pages of *Artforum* during the 1970s also provide valuable insight into Bochner's formative artistic development.

2 Bochner did have the opportunity to exhibit several of his photographs in influential shows in the late 1960s, but never as a cohesive body of work. This difficulty owed largely to critical and market biases against photography within the context of the art world during the years in which Bochner was seriously involved with the medium. The essay that follows discusses these circumstances and Bochner's limited exhibition of his photographs in greater depth.

3 First coined by John Chandler and Lucy Lippard in 1968, the phrase "the dematerialization of art" has become perhaps the most widespread (if contested) description of Conceptual art from the late 1960s through mid-1970s. See John Chandler and Lucy Lippard, "The Dematerialization of Art," *Art International* 12 (February 1968): 31–36; and Lucy Lippard, *6 Years: The Dematerialization of the Art Object from 1966 to 1972* (New York: Praeger, 1973).

4 This "documentary" emphasis is widespread. To cite just one example, in his catalogue on Robert Smithson's photography, Robert Sobieszek claims that along with Jan Dibbets, Hamish Fulton,

Richard Long, and others, Smithson "turned to photography as a convenient means of recording the various terrains he visited and explored. . . . For Smithson, photography was principally a straightforward means of documentation." Robert Sobieszek, *Robert Smithson: Photo Works*, exh. cat. (Los Angeles: Los Angeles County Museum of Art; Albuquerque: University of New Mexico Press, 1993), 16. While photography undeniably served a documentary function in Smithson's oeuvre, his work and writings belie the assumption that he considered the camera at all "straightforward," or that he even trusted the veracity of the instrument, which he claimed "possess[es] the power to invent many worlds." For Smithson, and especially for Dibbets (see note 62 of the following essay), photography demands to be treated almost as a "participant" in the creation of the work, because the camera opened up the possibility of engaging ideas that they could not have specifically explored without it.

5 In one of the most insightful and now much-cited discussions of photography and Conceptual art, Jeff Wall argues that in examples such as these, Conceptual artists enabled photography to become fully engaged with the artistic aims of Modernism as defined by painting. Wall argues that because photography was always inherently tied to depiction, any search for its "essence" would lead to "reportage," preventing the medium from ever fully achieving Modernist painting's putative autonomy. However, rather than accepting Conceptual photography's "documentation" as such, Wall claims that Conceptual artists were able to subvert the very notion of "reportage" by recording absurd, staged activities (as in the work of Douglas Huebler and Bruce Nauman, among others). In addition, he claims that through the process of "deskilling," or "amateurization," Conceptual photography's rejection of pictorial sophistication in favor of a snapshot aesthetic functioned analogously to Modernist painting's renunciation of technique, such as chiaroscuro or perspective. Although this pair of theoretical trajectories might apply to numerous examples of photographs by Conceptual artists, as we will see, Bochner's work is little involved with the notion of documentation as a subversion of "reportage." Furthermore, the majority of his photographs are so highly crafted (even if by outside photographers and labs) that his work rarely shares the "snapshot" aesthetic of so many of his contemporaries.

See Jeff Wall, "Marks of Indifference": Aspects of Photography in, or as, Conceptual Art," in *Reconsidering the Object of Art: 1965–1975* (exh. cat.), eds. Ann Goldstein and Anne Rorimer (Los Angeles: The Museum of Contemporary Art; Cambridge: The MIT Press, 1995), 247–67.

6 Benjamin Buchloh has provided a notable exception in his 1977 discussion of Dan Graham's early magazine pieces by pointing out the surprise and difficulty that Minimalist artists and mid-sixties critics had in understanding Graham's work as "art," rather than as "photojournalism." See Benjamin H. D. Buchloh, "Moments of History in the Work of Dan Graham," republished in *Conceptual Art: A Critical Anthology*, eds. Alexander Alberro and Blake Stimson (Cambridge: The MIT Press, 1999), 376–87.

7 Benjamin H. D. Buchloh, "Conceptual Art 1962–1969: From the Aesthetic of Administration to the Critique of Institutions," republished in *October: The Second Decade* (Cambridge: The MIT Press, October Books, 1997), 119. For Buchloh (as well as other writers) this transition from "object" to "definition" is directly indebted to Duchamp's "readymade," with its shift in emphasis from the visual character of the object to the linguistic statement that designates an object as art.

8 Joseph Kosuth, "Art as Idea as Idea: An Interview with Jeanne Siegel," WBAI-FM, 7 April 1970, republished in Joseph Kosuth, *Art After Philosophy and After*, ed. Gabriele Guercio (Cambridge: The MIT Press, 1991), 50. In 1969, Kosuth summarily dismissed the importance of morphology or form in favor of a purely linguistic model of Conceptual art (and art in general): "A work of art is a tautology in that it is a presentation of the artist's intention, that is, he is saying that a particular work of art is art, which means, is a *definition* of art. Thus, that it is art is true *a priori* (which is what Judd means when he states that 'if someone calls it art, it's art')." Kosuth, "Art After Philosophy," in Kosuth, *Art After Philosophy and After*, 20.

9 Kosuth, "1979," in *Symposium über Fotografie*, exh. cat. (Graz: Akademische Druck-u. Velagsanstatt, 1979), republished in Kosuth, *Art After Philosophy and After*, 187.

10 Sol LeWitt, "Paragraphs On Conceptual Art," *Artforum* 5 (June 1967): 80. Alexander Alberro has commented on the distinction between this model of a perceptually informed Conceptualism and a more linguistically predetermined model: "Unlike Kosuth's aesthetic theory, which posits that the idea itself can be considered the art, for LeWitt the process of conception stands in a complementary relation to the process of realization, mutually supplying each other's lack, and thus of equal importance." Alexander Alberro, "Reconsidering Conceptual Art, 1966–77," in *Conceptual Art: A Critical Anthology*, eds. Alberro and Blake Stimson (Cambridge: The MIT Press, 1999), xx.

11 Bochner has repeatedly objected to the label "Conceptual art" in reference to his work. In 1970, he wrote: "For a variety of reasons, I do not like the term 'Conceptual art'. . . . By creating an original fiction, 'Conceptualism' posits its special non-empirical existence as a positive (transcendent) value. But no amount of qualification (or documentation) can change the situation. Outside the spoken word, no thought can exist without a sustaining support." Mel Bochner, "Excerpts from Speculation," *Artforum* 8 (May 1970): 70. Bochner's objection to the term "Conceptual" does not entirely discredit the use of that label in reference to his work, since the term has come to describe a variety of practices with which Bochner's work might be reconciled. However, his concerns must be taken as a caveat against accepting a limited understanding of "Conceptualism" based on a purely linguistic model. Throughout the course of the following essay, we will see how Bochner's experience in photography led him to reject that understanding of Conceptualism and to eventually claim, "Works of art are not illustrations of ideas." Ibid., 71.

12 Admittedly, Bochner himself refers to photography as an "expedient" in a statement for the catalogue of *Art in Series*, a 1967 exhibition he helped Elayne Varian organize at the Finch College Museum of Art in Manhattan. However, as I will argue, photography ultimately proved less a simple "expedient" than Bochner could ever have imagined, and the medium repeatedly refused to comply fully with the plans he may have had at the outset of a particular work. See Mel Bochner, "Seriality and Photography," in *Mel Bochner*, exh. cat. (Rio de Janeiro: Centro de Arte Hélio Oiticica, 1999), 54. Originally published as artist's catalogue statement in *Art In Series*, exh. cat. (New York: Finch College Museum of Art, 1967).

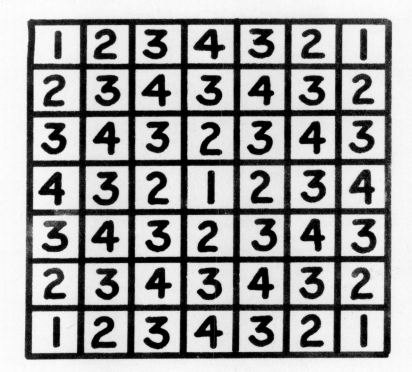

FIG. 1

Mel Bochner, *(N+1) Center Sets (Row I)*
(Detail from *36 Photographs and 12 Diagrams*), 1966.
Ink on cardboard, 8 x 8 in. (20.3 x 20.3 cm).
Städtische Galerie im Lenbachhaus, Munich

"Photography Cannot Record Abstract Ideas" and Other Misunderstandings

The Serial Attitude

In December 1966, Mel Bochner and the gallerist Virginia Dwan puzzled over a stacked arrangement of little wooden blocks and faced an unusual curatorial problem. Dwan, one of the most influential dealers of new art, had come to the twenty-six-year-old Bochner's Manhattan studio in search of work for her *Scale Models and Drawings* exhibition, to be held the following January.[1] At the time of her visit, she found the artist in the midst of a group of block constructions based on gridded diagrams, seven units to a side (fig. 1). Using simple mathematical patterns, Bochner would assign a value to each of the forty-nine spaces, either leaving them blank or filling in a number from 1 to 4. That drawing would then serve as a plan for a small construction of two-inch black wooden cubes, which Bochner would stack according to the numerical values on the grid. The number written in each square indicated how many blocks were to be piled in a given position—four blocks were stacked in positions corresponding to squares marked "4," three blocks for "3," and so on. Each day Bochner would adjust the stacks to match a variation on the numerical sequence, consequently destroying the previous structure, which he considered neither a maquette for a larger object nor a sculpture to be exhibited by itself. And therein lay Dwan's curatorial problem.

The gallerist hoped to show the little constructions in *Scale Models and Drawings*, but Bochner had reservations. For him, they were not to be seen as autonomous sculpture, but rather as individual steps in a larger serial process. Dwan suggested that the gallery assistant could rearrange the blocks each day, but Bochner remained unsatisfied with that solution, because any given visitor would never know what structure had appeared the day before or what permutation would develop next. Without that information, the viewer would have no way of apprehending the underlying system, which Bochner deemed the most important aspect of the work. As opposed to building the stacks one at a time, as he had been doing on his studio table, Bochner could have exhibited several of the arrangements together, thereby

emphasizing the common serial logic that generated and linked them. This solution would have been similar to the serial progressions of geometric structures shown that year at the Dwan Gallery by artists such as Sol LeWitt and Robert Smithson. Yet Bochner rejected that option too, because, as he later wrote, "I realized that the physicality of the objects I was making interested me less than the types of order I was imposing."[2]

To better understand precisely what type of "order" Bochner hoped to stress by turning away from fixed objects, we need only survey the development of serial principles that, since the late 1950s, had begun to proliferate as a means for motivating art opposed to traditional composition. Bochner, who also wrote criticism in the mid-sixties, provided an excellent map of that trend in his 1967 *Artforum* article, "The Serial Attitude." In that text, he defined seriality as a "method," not a style, wherein "the derivation of the terms or interior divisions of the work is by means of a numerical or otherwise systematically predetermined process." Examples ranged from "arithmetic progression," in which "succeeding terms are derived by the addition of a constant number," to "rotation," which subjects the terms of the series to regular axial turns. Bochner traced the contemporary resurgence of these methods to the work of a broad range of artists, including Frank Stella, Andy Warhol, Robert Rauschenberg, Ellsworth Kelly, and Jasper Johns. Of these precedents, Johns's 1950s number and alphabet paintings represent perhaps the strongest examples of the "serial attitude," in that they were entirely "self exhausting" and "solipsistic," with predetermined systems dictating the successive terms in a painting: "D" always followed "C," as "8" invariably anticipated "9" (fig. 2).[3]

Although each of these artists served as a crucial model for Bochner's work, the art of Donald Judd, Dan Flavin, Robert Smithson, Sol LeWitt, and other so-called Minimalists provided Bochner's most immediate and compelling point of contact with serial thinking. Like Kelly and Stella, Judd had turned his attention to systematic order as a strategy for disavowing Abstract Expressionism's supposed spontaneity and the traditional compositional hierarchies based on balancing the various parts of a painting or sculpture.[4] By placing "one thing after another," as in his rows of boxes or stacks (fig. 3), Judd was able to make anti-illusionistic, multipart works, which resisted uneven or arbitrary compositional emphasis among the repeating elements. In his more irregular-looking reliefs begun in 1965, he introduced increasingly complicated and genuinely serial schemas such as the Fibonacci series, making "it possible to use an asymmetrical arrangement, yet to have some sort of order

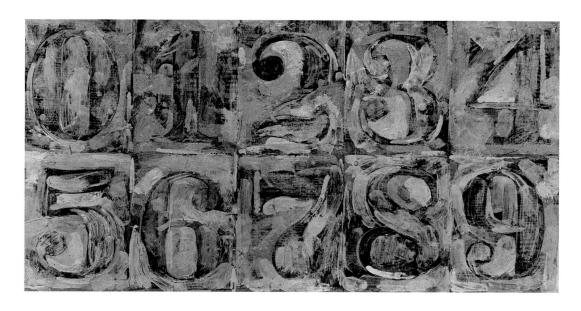

FIG. 2

Jasper Johns, *0 Through 9*, 1958. Encaustic and collage on canvas, 12 3/4 x 23 in. (32.4 x 58.4 cm)

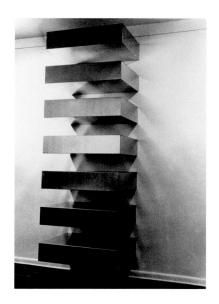

FIG. 3

Donald Judd, *Untitled*, 1970 refabrication of 1966 original. Galvanized iron, 10 units, each 9 x 40 x 31 in. (22.9 x 101.6 x 78.7 cm), hung at intervals of 9 in. (22.9 cm). Locksley Shea Gallery, Minneapolis

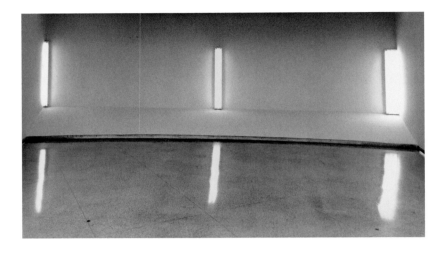

FIG. 4

Dan Flavin, *the nominal three (to William of Ockham)*, 1963. Fluorescent light fixtures with daylight lamps, edition 2 of 3, each unit 72 in. in height (182.9 cm), width dimensions variable. The Solomon R. Guggenheim Museum, New York, Panza Collection

not involved in composition."[5] Like Judd, Flavin also invoked a variety of modular and serial structures to order his work with store-bought light fixtures. Of all these pieces, Bochner was particularly struck by Flavin's 1963 *the nominal three (to William of Ockham)* (fig. 4), a series of five identical white fluorescent lights affixed to the wall in a three-part additive progression. In contrast to Judd's less self-evident number sequences, *the nominal three* clearly reveals its simple, serial order, with each term iconically representing its underlying numerical value, as in a tally, I II III.[6]

Seizing on the modular and serial qualities in the Minimalist work of Judd and Flavin, other artists, most notably LeWitt, underscored their engagement with those systems by making more overtly legible that which had previously been implicit. In *Serial Project #1 (ABCD)* of 1966, LeWitt covered a large grid with an intricate array of open and closed cubic forms organized in four quadrants (fig. 5).[7] Although at first glance it may seem complex, after some reflection LeWitt's *Serial Project* quite easily divulges its system. As opposed to the large-scale "wholeness" espoused by Judd, LeWitt specifically contrasted the heights and widths of *Serial Project's* various parts as a means of foregrounding the particular schema or "idea" behind the work, arguing that "the differences between the parts are the *subject* of the composition" [my emphasis].[8] Here, then, we can begin to discern the roots of LeWitt's brand of Conceptual art, wherein "the idea or concept is the most important

aspect of the work."[9] And, as James Meyer notes, "*Serial Project*, insofar as it foregrounded the idea's primacy in its production, opened up the possibility of a post-serial Conceptualism, an investigation of other 'concepts,' other processes."[10]

This turn toward a conceptual art wherein a preconceived mathematical or "linguistic" schema manifested itself so insistently as the "subject" of the work was precisely the point at which LeWitt and Smithson, as well as Bochner, might be said to break with Minimalism as characterized by Flavin, Carl Andre, and, most important, Judd. For although the latter group depended on modular and serial systems to avoid compositional choice, they never intended for those systems to reveal themselves as the subject of the work or claim pride of place in the viewer's attention.[11] In fact, Judd insisted on the relative unimportance and even obfuscation of his underlying series.

FIG. 5

Sol LeWitt, *Serial Project #1 (ABCD)*, 1966. Baked enamel on aluminum, 20 x 163 x 163 in. (50.8 x 414 x 414 cm). The Museum of Modern Art, New York, gift of Agnes Gund and purchase (by exchange)

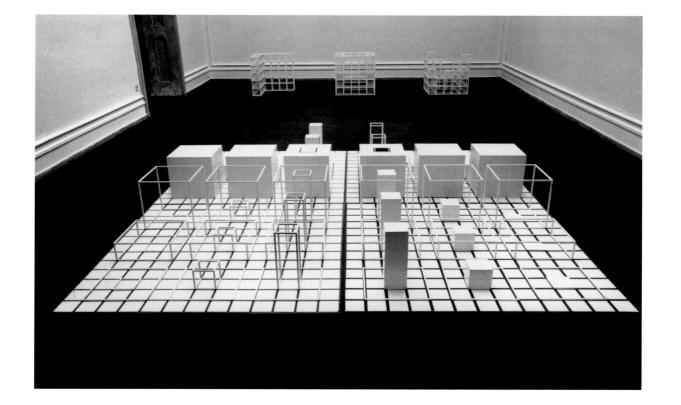

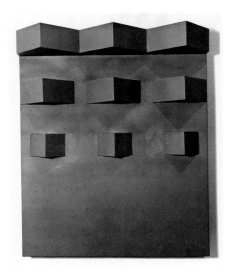

FIG. 6

Mel Bochner, *One, Two, Three*, 1966. Sheet iron painted purple, 30 x 24 x 8 in. (76.2 x 61 x 20.3 cm). Collection of the artist

According to Meyer, Judd thought art "should not require—it should indeed avoid—the supplement of a linguistic analogy"—a caveat that led him to disapprove of LeWitt's foregrounding of the schema rather than the purely perceptual, physical object.[12] Whereas Judd used serial systems as a hidden means for generating objects, LeWitt inverted the emphasis so that the three-dimensional work appeared to serve simply as a mechanism for describing those serial systems. Yet, if Judd saw this shift in stress as leaning too far toward the a priori, the "linguistic," Bochner thought LeWitt had not gone far enough.

By 1966, little more than two years after reaching New York, Bochner had devoted himself almost entirely to an art based on numerical systems and progressions. Like Judd, he experimented with reliefs, such as the sheet iron *One, Two, Three* (fig. 6), in which triangular forms project incrementally from a flat, even ground. But this relief, along with others executed in cardboard and balsa wood, often prove less engaging than their studies, in which mathematical systems claim space alongside diagrams of the objects they might engender. At the bottom of several such drawings on isometric graph paper, Bochner precisely penned a mathematical progression, each term of which contains numbers indicating the dimensions of a cubic solid (fig. 7). Above that sequence, Bochner would carefully diagram the object it generated, which he would sometimes build in cardboard. Often, though, an object was never executed, or, in fact, never intended. For example, many of Bochner's drawings on graph paper experiment solely with the geometric organization of number sequences, which sometimes fill rectangular grids, as in Johns's paintings. Yet rather than always "pouring" the numerical sets into closed rectangular forms, Bochner often counted in different directions across the sheet in columns, bars, diagonals, or zigzags (fig. 8). These drawings, with their scratched-out corrections and disorganized accumulations of jagged triangles and perfect swastikas, betray Bochner's tentative striving to give a priori sequences shape, without entirely subsuming those series in purely formal abstractions.

By the time Dwan visited Bochner's studio to find a piece for *Scale Models and Drawings*, the link between the sequence and its physical embodiment in his work had grown so attenuated that there was almost nothing left for her to show. At this point, he had begun the simple seven-by-seven gridded drawings, themselves only plans for constantly vanishing constructions. Bochner had altogether abandoned the idea of making fixed "sculptures" from the patterns, since he saw them only as steps in an ever-progressing sequence, and he was no more eager to display the gridded diagrams as self-sufficient

7

FIG. 7

Mel Bochner, *Untitled (Study for 6-Part Horizontal Progression)*, 1966. Pen and ink on isometric graph paper, 8 1/2 x 11 in. (21.6 x 27.9 cm). Collection of the artist

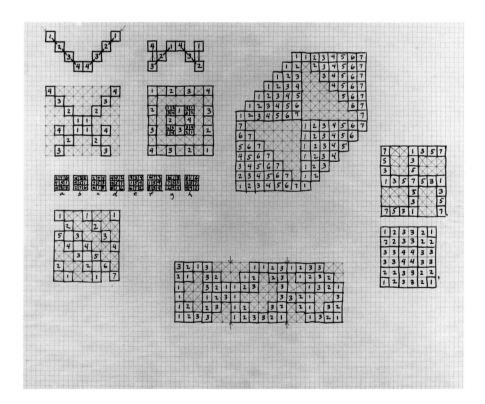

FIG. 8

Mel Bochner, *Untitled (Number Drawing with Swastika)*, 1966. Pen and ink on graph paper, 16 x 20 3/4 in. (40.6 x 52.7 cm)

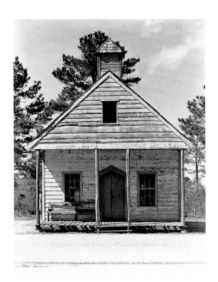

FIG. 9
Walker Evans, *Negro Church, South Carolina*, 1936.
Gelatin silver print, 8 3/8 x 7 3/8 in. (21.3 x 18.7 cm).
Courtesy of the Library of Congress

work.[13] To understand this last objection, we must consider Bochner's project against the backdrop of the minimal sculpture from which it evolved. As we have already seen, he found the serial logic underpinning Minimal art to be among its most compelling aspects. Yet, if those systems were always burdened by the rhetoric, not to mention literal weight, of an insistent physicality, then the viewer might never fully grasp the sequence as the true "subject" of the work. Even if LeWitt and Smithson had done much to reorient one's attention toward the underlying premise, the most simple schemas still lay trapped in a dizzying array of sculptural production, seen by a circumambulatory viewer. Had Bochner chosen simply to exhibit his diagrams with Dwan, he would have avoided this circumstance. However, he would also have avoided defining his work explicitly in relation to the very minimal sculpture whose serial secrets he sought to unveil. Eventually, he struck on photography as a solution that might balance the schema *and* its embodiment, without tipping the scale under the weight of the object.

A Minimalist Photography?

Although photography may have seemed an obvious answer to Bochner's problem, adopting the medium in 1966 was neither a likely nor easy thing to do. After all, Bochner had absolutely no experience with photography, and it would hardly have recommended itself to anyone interested in serious new art. At that time, the medium was so frowned upon by the art world that one gallerist suggested he might show Bochner's photographs only after they were silk-screened on canvas.[14] This absurd response reflected the acceptance of photo-reproductive technologies within the context of painting, as in the work of Rauschenberg or Warhol, although photographs on paper still occupied a separate sphere from what was considered the most advanced painting and sculpture.[15] Such a disparaging view was not limited to the market, but also pervaded the art press, having gained particularly cogent rationale in the criticism of Clement Greenberg.[16] Yet even more daunting than these biases, Bochner faced implicit opposition to photography in the anti-illusionistic claims of the Minimal art he so greatly admired. Judd, in his own writing, had already condemned even the most abstract painting for its inevitable spatial illusionism, leading him to advocate a nonrepresentational art that existed in real space, just as any other object would. "Three dimensions are real space," he wrote. "That gets rid of the problem of illusionism."[17] Photography was so far from Judd's realm of possibility that it escaped his reproach altogether.[18]

FIG. 10

Ed Ruscha, Detail from *Twentysix Gasoline Stations*, 1963. Black offset printing on white paper

Despite the antipathy between photography's inherent illusionism and Minimalism's insistent physicality, Bochner relied on photographic models that might be made somehow amenable to the terms of Minimal art. In approaching his newly chosen medium, he drew heavily on Walker Evans's pre-war photography and the books of Ed Ruscha, who was among the first artists in the sixties to use unmodified black-and-white photographs in his work. Bochner was particularly impressed by the plain, unemotional composition of Evans's starkest architectural images, which often eschew traditional com-position by presenting a symmetrical facade, centered and parallel to the picture plane (fig. 9). Ruscha, himself an admirer of Evans, offered Bochner a more contemporary photographic model, both in his serial deployment of the medium and the deadpan look of his images.[19] In Ruscha's books, such as *Twentysix Gasoline Stations* (fig. 10) and *Thirtyfour Parking Lots* (1967), he assembled a collection of almost generic, taxonomic photographs, each indivi-dually insignificant outside the larger context of the work. Bochner clearly appreciated this use of photography, which shifted attention from single images to the overall sequence indicated by the book's title, a linguistically prede-termined premise with which Ruscha always began. Bochner also prized the straightforward, uncontrived appearance of the photographs, which Ruscha claimed were never "arty," but more akin to snapshots or "technical data like industrial photography."[20] Yet despite their lack of pictorial effect, Bochner

must have still found Ruscha's pictures a bit too casual for his own purposes, since extraneous details and background information had a habit of seeping in from the margins and disturbing a given subject's isolation.[21] In contrast, Bochner hoped for even more restrained, more emphatically "technical" photographs, so he found someone else to take them.

By hiring a professional to make *36 Photographs and 12 Diagrams* (plate 1), Bochner happily substituted a carefully controlled, almost scientific finish for the signature finesse of the photographic auteur, which he did not happen to be.[22] Although Bochner's refusal to release the shutter himself would have been highly unorthodox—even suspect—within the context of traditional fine art photography, his pragmatic method and uninflected style derived from Minimalism's industrial production. As he explained, "Anytime I became involved with the craft aspect, there was the danger of looking old fashioned. By using the fabrication techniques of Minimalism, it gave me a certain objectivity."[23] To achieve that appearance of "objectivity," he devised a system wherein each block construction would appear almost as an isolated specimen, floating on an evenly lit, seamless white ground. Bochner had the professional photographer Gretchen Lambert shoot each of twelve constructions from three fixed viewpoints, which were borrowed from architecture's standard means for describing a three-dimensional form in space.[24] For the "plan," he positioned the camera directly over the object; for "elevation," the camera was aligned level with the structure and perpendicular to its "facade"; and for "perspective," the photograph was taken above one corner, in line with the diagonal axis. The final work included three photographs of each construction arranged in vertical columns capped by the original gridded drawings.

Bochner's spare, almost clinical, approach to photography deserves some attention, since it may not be immediately clear just what he hoped to be "objective" about. "Objectivity," generally defined, has long carried a heavy significance with regard to the camera, especially in terms of its claim to veracity, its documentary power to record a particular image faithfully.[25] Yet, while that claim may have been indispensable for a photographer such as Evans, the assertion of verisimilitude would seem irrelevant for Bochner, given that the blocks were throwaway constructions, not independent works to record meticulously. Instead, we might consider Bochner's interest in "objectivity" within the historically specific context of writers such as Alain Robbe-Grillet and Minimalism's reliance on both machine fabrication and mathematical systems to avoid "subjective" composition and irregular pictorial effect.[26] As we have seen,

Judd praised anti-illusionistic, noncompositional art that, like common objects, shared space with the viewer and had no pretensions to be or describe anything they were not. Within this framework, "objective" signifies that a work is anti-illusionistic and uninflected; it is what it is.[27] Given Bochner's extremely close relationship to Minimalism, this notion of "objectivity" would have been unavoidable and was directly paired with his understanding of "literalism," which he cited as a central goal of his early photography and defined as follows: "the thing is the thing and not a representation of the thing; there's no mediation at work."[28]

Ironically, to apply this criterion to photography stringently would seem a naive, ill-fated endeavor, because the medium is necessarily indirect, illusionistic, and therefore mediated. Nevertheless, Bochner understood that if he was to return to the taboo realm of two-dimensional representation, he would have to inoculate photography against the charge of illusionism by making it just as objective and therefore as literal as the Minimalist object was presumed to be.[29] The dream of photography's dispassionate objectivity seduced Bochner, and he attempted to demonstrate the "literalism" of his photographs through an absolute insistence on their innocence of any interpretive filter or authorial inflection. He placed himself outside the work by hiring Lambert and then labored to drain the images of any excess figural detail or "subjective" touch that might have insidiously opened the block constructions up to authorial expression or semantic possibility beyond their simple existence as steps in a serial process. In photography, Bochner saw the paradoxical promise of a medium so completely illusionistic as to sidestep the problem of illusionism altogether. If photographed properly, the blocks could be presented so plainly, so objectively that they would appear somehow unmediated, yet still so physically unencumbered as to avoid overshadowing the serial order they were charged to convey.

First Misunderstandings

Once Bochner's images had achieved this lapidary clarity, he devised a gridded presentation to establish their underlying serial order. He carefully grouped the panels in four discrete sets, based on the original numbered diagrams, which he included in the work to underscore the relationship between the schema and the constructions.[30] Moving across the sets from left to right, the blocks vary according to differences between the numerical plans, so that each transition reveals an incremental change in the progression. This organization owed

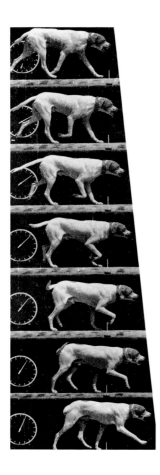

largely to the models of late-nineteenth-century stop-action photography by Etienne-Jules Marey (fig. 11), Thomas Eakins (fig. 12), and, most importantly, Eadweard Muybridge (fig. 13), whose work Bochner saw as "the serialization of time."[31] Fittingly, LeWitt had also been drawn to Muybridge and in 1964 executed two works bearing the photographer's name, both of which show a nude woman drawing progressively nearer in ten photographs placed behind a row of peepholes.[32] Although LeWitt capitalized on Muybridge's incremental depiction of motion, Bochner approached the source with greater attention to Muybridge's simultaneity. In LeWitt's peephole structures, it is impossible to see more than one image at a time, whereas Bochner provides all the images at once. By purposefully displaying every step of the sequence together, Bochner makes the system wholly manifest as the subject of the work. Further, the very structure of the block stacks internalizes the gridded background Muybridge often used to gauge the movement of his figures. In Bochner's photographs, at least in "plan" and "elevation," the structures actually provide the grid: the blocks' edges mark the division between the individual units, making it possible to count off their position and thereby apprehend the overarching logic of the work.

Yet for all Bochner's obsessive pains in the service of a systematic perspicuity, *36 Photographs and 12 Diagrams* may obscure more than it clarifies. Certainly, we can follow the progress of the sequences horizontally across the rows. After some work, we may even be able to determine the connection between the numbers on the gridded drawings and the height of the blocks, but those relationships, of which we can make perfect sense, do little to make the work seem any more sensible. For just as the bond between the system and the structures is revealed, everything grows more arbitrary, more absurd—not despite, but because of its pretensions toward a pellucid, predetermined logic.[33] The changes between two steps in a sequence are often impossible to determine from the images without reference to the drawings, and we begin to wonder how Bochner chose the particular mathematical sets, what rule unites them, and why the number of steps varies between them. Perhaps most bewildering of all, the constructions themselves reveal a startling duplicity. Once simultaneously subjected to three different viewing angles, these presumably simple, symmetrical forms unravel with an almost cubist complexity. The swastika-planned pile proves entirely unrecognizable in perspective, while a simple cross resists easy identification in elevation (fig. 14). Instead of behaving for the camera as Bochner intended, all the blocks resist easy

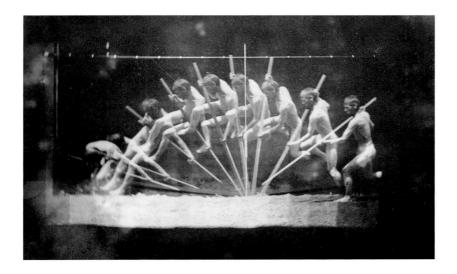

FIG. 12

Thomas Eakins, *Motion Study: George Reynolds nude, pole-vaulting to left*, 1885. Gelatin silver print from dry plate negative, (negative size) 3 7/8 x 4 5/8 in. (9.8 x 11.7 cm). The Pennsylvania Academy of the Fine Arts

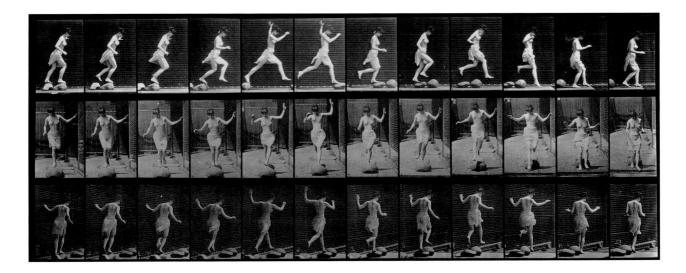

FIG. 13

Eadweard Muybridge, *The Attitudes of Animals in Motion (Woman Leaping)*, 1887. Collotype, 7 x 17 1/4 in. (18 x 43.8 cm). Fogg Art Museum, Harvard University Art Museums, purchased through the generosity of Melvin R. Seiden

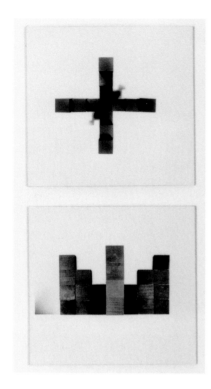

"objectification." So, rather than conferring a sense of "objectivity" or "literalness" on the structures, the systematic combination of views does precisely the opposite, making it extremely difficult to reconcile two different photographs of the very same construction.[34]

Here Bochner struck upon a key criticism of Judd's anti-illusionist rhetoric, which called for the Minimalist object's "wholeness," both in its avoidance of compositionally related parts and its refusal to yield different information or pictorial views from various vantages. Of course, given a viewer's perception of an object in time and space, this last requirement was for the most part impossible, unless the object was even simpler than most of Judd's and could be immediately apprehended as a unified gestalt.[35] Both Rosalind Krauss and Robert Smithson had already identified the inevitable illusionism of Judd's own materials and structures, which often looked different from the side than one might have expected based on a frontal view.[36] Robert Morris posed this problem convincingly in works such as *Untitled (Two L-Beams)* (fig. 15), which simultaneously confronted the viewer with two identical objects in different positions. Nevertheless, Judd's "wholeness" bias had lingered, and it was difficult to contradict it explicitly in sculpture, because a viewer can never actually compare contrasting views of the very same object at the very same time.[37] Photographs make this simultaneity easy, but nothing had prepared Bochner for just how stridently his work would make this point.

Once installed at Dwan, *36 Photographs and 12 Diagrams* surprised its creator. As Bochner recalls, "I suddenly knew that the issues of literalism and anti-illusionism that I had been thinking about had disappeared, because this work was totally illusionistic and completely anti-literal. . . . It was the illusion of literalism."[38] Nowhere was this fact more apparent than in the individual photographs themselves, which despite Bochner's best efforts to the contrary, could not depict the blocks as transparently as he had hoped. No matter how carefully lit, the objects cast shadows, adding extraneous pictorial incident and betraying the surface on which the blocks mysteriously seemed to hover. In addition, patches of wood grain on the blocks' surfaces lent a sense of scale to the apparently scaleless structures. Even if we were unaware that each block measured two inches on a side, we could guess that they were larger in life than in the photograph, since the grain of the wood in the picture seems too finely packed to be full size. Though just barely perceptible, this disjunction is extremely significant with regard to Bochner's recognition that the photographs were "completely anti-literal,"

since any shift in scale emphasizes the structure as mediated, and therefore not the thing itself.

Even more noticeably, the camera warped the perfectly linear structures through perspective and the spherical distortion of the lens. In the oblique overhead photographs at the bottom of each column, the blocks' vertical edges bend gently toward the frame, while the bottom edges push in slightly toward the center. Looking at the pictures shot from directly above, we find similar distortions. For example, in the two images at the upper right, the structure appears to curve in on the sides and bow out toward the corners, although we know from the plan that the outside edges should be perfectly square. Such curving can be explained by the fact that the structure grows taller at the corners, but given that the four blocks at each end are stacked directly on top of one another, we might expect a photograph in "plan" to still maintain the perfect square. Instead, the higher blocks seem out of line with the lower ones, refusing to be pictured on the very same axis where we know them to be. This jagged, tilting edge corrupts the geometric perfection of all the structures shot from above, since perspective forces each side to be seen as a plane canted like the wall of a pyramid toward a vanishing point centered behind the image. By juxtaposing these images with the perfectly square plans, Bochner makes an otherwise ordinary visual phenomenon all the more jarring and strange—a rupture he would seize on in later works.

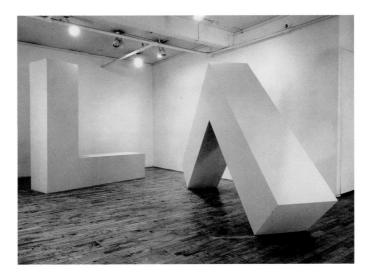

FIG. 15
Robert Morris, *Untitled (Two L-Beams)*, 1965.
Painted plywood, two units, each 96 x 96 x 24 in.
(243.8 x 243.8 x 61 cm)

Once a viewing condition such as perspective or scale reveals itself in Bochner's photographs, the images are doomed never to realize his quixotic goal of an unmediated literalism, since the structures always announce themselves *as* mediated, as having been viewed through the camera from a particular vantage and distance. In that sense, *36 Photographs and 12 Diagrams* falls short of delivering what Bochner had asked of it, but not for lack of trying. No matter how carefully constructed, how scrupulous his personal disavowals, the photographs could never be so perfectly "objective" as to convince the viewer of their literalism, their transparent evocation of the block structures unfiltered by the screens of representation.[39] Nevertheless, Bochner's failure to entirely discipline the camera would also prove to be his greatest success.

From Image to Object

By rubbing up against photography's stubborn resistance to act as transparently as he had hoped, Bochner was forced to notice the idiosyncrasies of the medium and the difficulties in creating a fully "conceptually" predetermined art. In the works he made just after his photographic debut, Bochner was challenged to rethink his original interest in a literalist photography and the unfettered seriality it might convey, a process that opened up new avenues of exploration. For an exhibition in the spring of 1967 at the Museum of Contemporary Crafts in New York, Bochner elegantly distilled the system he had devised for *36 Photographs and 12 Diagrams*. *Photograph-Blocks (Four by Four)* (plate 5) includes Bochner's standard order-seven diagram with a "1" marked in every other space in every other row. As with his earlier piece, he constructed a block "set-up" and had it photographed from the same three vantages he had already employed.[40] The more pared-down arrangement he now used might be seen to acknowledge the overly complicated structures and systems at play in *36 Photographs and 12 Diagrams*, which do not divulge their logic nearly as easily as *Four by Four* does. Even so, odd shadows still spring from the blocks, and perspective again surfaces in unforeseen ways. In the overhead photograph especially, we might imagine an angle from which each of the sixteen blocks would appear as perfect squares. This is almost true of the four central blocks, but those on the outside of the image sprout scarcely visible edges sliding toward a vanishing point, as do the blocks photographed in elevation.

After this piece, Bochner temporarily surrendered his struggle to "literalize" what was pictured in the image, and focused instead on making the serial structure even more literally apparent through the physical manipulation

of the photographic print itself. In *None Tangent* (plate 7), he enlarged one of the same negatives used in *Four by Four* and then cut the print into sixteen equal squares, which he mounted on separate Masonite panels and hung in a grid about one inch apart. Here, Bochner's quest for literalism in the service of seriality grew extremely explicit, in that the physical division of the image mimics the basic gridded structure of the blocks in the photograph. Yet again, odd ruptures prove irrepressible. A strong tension develops between the perspectival regression of the blocks in space and the insistently flat, tilelike grid of separate panels in which they sit, a disjunction underscored by the disposition of the blocks in a diamond pattern torqued against the perpendiculars of their gridded support. Whereas before the fissures between one of Bochner's systems and its depiction felt more accidental, in this case he seems to have intentionally targeted that disruption. Had Bochner wished to avoid this circumstance, he could have divided the overhead photograph from *Four by Four* to yield exactly one block for each square, the border of the print more or less parallel to the edges of the block. Instead, his choice indicates that he had grown interested not only in the relationship between the mathematical sequence and the block structure, but also in the tension between the photograph as a physical object and the image described within.

Now, each photographic fragment was as open to manipulation as the blocks depicted inside the frame had once been. Bochner expanded on this discovery in *Sixteen Isomorphs (Negative)* (plate 8), a large installation of sixteen photographic panels with an overall span of nearly twelve feet. To create the work, Bochner broke *None Tangent* into four quadrants of four panels each and rearranged them on his studio wall in variations based on reversals, axial rotations, and other systematic manipulations. He had each of these sixteen arrangements photographed and then made negative prints, which he hung in a grid to create *Sixteen Isomorphs*. For the work's final form, Bochner devised an ingenious *mise en abyme* organization of perfectly complementary parts: each image in the overall grid of sixteen photographs contains the faint outline of the sixteen panels of *None Tangent*, which refer to the original arrangement of the sixteen wooden blocks.[41]

By rearranging the photographic panels of *None Tangent*, rather than adjusting the original block structures as he did in *36 Photographs*, Bochner finally created a serial system completely disembodied and unconstrained by the physical limits of the blocks as they would be perceived by a viewer.[42] Given their dizzying fragmentation and total lack of a unified perspective, as

well as the odd inversion of black and white, the panels are self-avowedly
photographs of photographs and are defiantly unembarrassed by their status
as such. Previously, Bochner had tried to achieve a kind of photographic
literalism by conceiving of the image as entirely unmediated and transparent,
but once that approach proved impossible, he redirected rather than aban-
doned his quest. In *None Tangent* and *Sixteen Isomorphs*, that meant violating
the integrity of the photograph as a transparent window so that its parts
function as literal objects, which could themselves be deployed in the service
of a serial system or structure.

 Bochner pushed this treatment of the photograph further in works such
as *Isomorphic Circles (Compass #1): Negative* (plate 10), in which he created
a target shape from the same image in *None Tangent*, and rotated its rings for
explosive effect. In *Magic Squares (Visually Random #1) A & B* (plate 11),
Bochner completely disassociated the image from its underlying system by assign-
ing each panel a numerical value, which determines its place in the overall
grid.[43] So, while the viewer sees the object as a "visually random" jumble, its
organization is based not on chance but on a rigorous mathematical schema,
which determines the arrangement of the photographic panels themselves. This
operation is clearly visible in a two-part drawing for an unexecuted photo-
graph (plate 60), which shows the image from *None Tangent* divided into
twenty-four numbered squares and then rearranged according to an extremely
simple mathematical system. Yet, the resulting arrangement looks so visually
complex that its order would be almost impossible to determine without the
numerals indicated in each square. Ultimately these works, which subjected
the actual photographic panels (rather than their contents) to serial manipula-
tions, led Bochner neither to discard his literalist cause nor to ignore the
representational filters and distortions the camera unavoidably imposed. Instead,
he developed a subtle understanding of the photograph itself as an object,
precariously poised between the world it describes and the one it inhabits.

Silhouettes

Once Bochner realized that he could act on the photograph itself as an object,
more radical interventions ensued. His next work, *H-2* (plate 3), inspires an
uncanny perceptual double-take. At first, the work is not even immediately
recognizable as a photograph but strikes the viewer as a sculptural relief. From
a distance, the blocks of the nearly four-foot square structure appear to push
forcefully into space. However, we eventually realize that the blocks' three-

dimensionality is entirely an illusion, since the surface of the work is absolutely flat. Bochner achieved this fantastic trompe l'oeil relief effect by combining photography with slightly sculptural means, maintaining the flat photographic surface while abandoning the neutrality of the traditional rectangular frame. He began by selecting an overhead shot from *36 Photographs and 12 Diagrams*, which he enlarged and mounted on Masonite. Then the border of the photograph and backing were cut so that the actual edge of the image corresponds exactly to the edge of the structure it depicts, a process akin to silhouetting an object from its background.[44] Finally, Bochner hung *H-2* about two inches off the wall, just enough distance to give the photograph a sculptural presence, which seems to far exceed the actual depth of the relief.

Although this approach would have been unusual in photography, sculptural reliefs were quite prevalent in the art of the mid-sixties, especially in the work of artists with whom Bochner had strong affinities, including Judd, LeWitt, Smithson, Flavin, Morris, and Eva Hesse.[45] However, those artists generally created their reliefs by varying the depth of projecting elements often rooted in a rectangular ground. Given that Bochner left his surface a perfect plane while modulating the outside edges, *H-2* might actually have more in common with the parallel trend of shaped paintings made on heavy stretchers that pushed the picture surface away from the wall. Of all the painters working in this mode, anthologized at the turn of 1965 in the exhibitions *The Shaped Canvas* and *Shape and Structure*, none figured more prominently than Stella, whose work of the early sixties already incorporated canvases in the shape of notched rectangles, diamonds, stars, and crosses, as well as cutouts showing through to the wall (fig. 16). In these pieces, the stripes on the

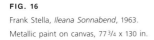

FIG. 16
Frank Stella, *Ileana Sonnabend*, 1963.
Metallic paint on canvas, 77 3/4 x 130 in.

surface were often seen to derive from the shape of the support and the direction of its axes, a technique Michael Fried termed "deductive structure" and hailed as a route to Modernist painting's self-reflexivity.[46] In *H-2*, Bochner inverted that process by trimming the perimeter of the object to match the content of the image, slyly undermining the logic of the "deductive structure" and the presumed inviolability of the camera's rectangular viewing frame.[47]

With *H-2* and *H-3* (plate 4) we should recognize that Bochner had slipped the grip of seriality for new theoretical terrain. By treating the block construction outside the context of a larger mathematical system, Bochner indicated his growing involvement with a set of concerns unforeseen when he turned to photography, but raised only after immersing himself within it. Now that serial schemas no longer announced themselves directly as the primary subject of the work, Bochner became far more invested in questions inspired by the ontology of the photographic object, its specific relation to contemporary painting and sculpture, and the ineluctable illusionism that continued both to tempt and to thwart his fascination with literalism. In one sense, we might see Bochner's silhouette process, which makes the photograph look even more like actual blocks, as his most desperate attempt to grasp an ever-elusive literalist photography. By removing the background from the original photograph, Bochner dispensed with the frame as a pictorial conceit, which would always have signaled the blocks as a mediated representation. *H-2* then raised the stakes in Bochner's wager with literalism by providing the viewer such a compelling, almost direct experience of the blocks that one might at first be convinced of their sculptural presence. But whatever literalism Bochner may have won through his objectlike treatment of the photograph was again paradoxically gained on the back of a persistent illusionism, an irrepressible means and threat to a "literalist" evocation of the unmediated "thing as the thing."

And again, even more than before, we are forced to recognize that the very tricks meant to persuade us of the blocks' seamless presence are the same attributes that invariably undermine the illusion. For example, the juxtaposition of the shadows within the image and those actually cast by the silhouette gives way to an odd rupture. The four open squares at the center of the work are actually holes that reveal the wall behind, as evidenced by the dark shadows caught in the recessed wells. These shadows, along with those around the photograph, do not comply with those cast by the block construction in the image. So, we are confronted by a perceptual disparity between the lighting of *H-2* in the gallery and the lighting of the original blocks within the

photograph. This kind of conflict extends a condition already apparent in *36 Photographs*, where lighting and perspective make the viewer aware that the blocks had been shot from a particular vantage and distance. Yet if *36 Photographs* indirectly acknowledged that point within its images, the work was not the least bit self-conscious about its own viewing conditions. In other words, it matters far less where the viewer stands in relation to those forty-eight panels than where the camera stood vis-à-vis the blocks or where one might stand in relation to a Minimalist object. With *H-2*, however, we are suddenly aware of the photograph itself—not simply what it pictures—as subject to particular viewing conditions. The circumstances of perception are then no longer coded only in the relationship between the camera and the blocks, but also in the relationship between the viewer and the silhouetted photograph, which so directly engages its surroundings.

That encounter between the object and the viewer was in many ways the implicit subject of much Minimalist sculpture, or even Barnett Newman's painting, for that matter. But in *H-2* we find a peculiar doubling, since the apparent object of our observation (the block construction) has already been subjected to the viewing conditions of the camera. Nowhere is the strangeness of this doubling more obvious than with regard to perspective, the phenomenon responsible for the strength and weakness of *H-2*'s illusionism. Looking directly at the work, we see how perspective determines the construction's jagged outline by dictating that the edge of those blocks farthest from the viewer (and the camera) converge toward the structure's central vanishing point.[48] This regression, combined with the silhouette format, ensures the depth of the image, its appearance of popping off the wall. Yet that effect is highly conditional, because the illusion does not necessarily hold from across the room, but only from *straight* across the room. As soon as one stands at an angle, perspective proves extremely inflexible, even fragile, like a stage-set facade that demands a particular viewpoint or stubbornly withholds its illusory rewards.

The moment we view *H-2* indirectly, its persuasive depth immediately collapses (fig. 17), and we are struck by the discrepancy between the perspective in the image and our own perspectively skewed view of the piece. This problem of a perfect viewing distance and angle was hardly new, having haunted the Western picture since the invention of perspective. Leonardo himself distinguished between "natural perspective" and "artificial perspective," the latter being the "natural" recession of objects observed by the eye, and the

former describing the "artificial" means by which an artist captures that impression.[49] So, just like any other object, a painting itself will necessarily be seen in perspective, thereby distorting even the most perfectly crafted spatial illusion within the image. *H-2* dramatizes that incongruity far more forcefully than most paintings or photographs, since its shaped support gives the image a strong three-dimensional presence, which conspicuously flattens under the slightest oblique pressure from our eye. This dilemma clearly fascinated Bochner, who had already witnessed his original block constructions flaunt wildly competing perspectives in the three vantages of *36 Photographs*. In addition, the rotations and reversals in works such as *16 Isomorphs* and the *Compass* photographs had reduced once perspectively coherent images to inconsistent spatial jumbles. Yet of all his earliest works, only *H-2* so explicitly pits the "artificial" perspective frozen in the photograph against the changing "natural" perspective of its viewing.

It is perhaps not surprising that perspective came to occupy Bochner's attention, since it had emerged not only as an unexpected consequence of his turn to the camera, but was also of crucial interest to artists and critics in the mid-sixties. As I have already mentioned, Judd's formulation of the specific object's "wholeness" and anti-illusionism would hardly have accounted for

FIG. 17
View of *H-2* from an oblique angle

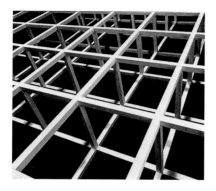

FIG. 18

Image from an advertisement for Sol LeWitt
exhibition at the Dwan Gallery, New York. Published
in *Art News* 65 (May 1966), p. 63

the fact that all Minimalist objects were necessarily seen from different per-
spectives as the viewer changed position before the work. Inspired by Merleau-
Ponty, Krauss noted this phenomenon in Judd's work, which she found far
less self-evident and anti-illusionistic than the artist would have allowed: "A view
raking along the facade of the sculpture, then, reveals one's initial reading
as being in some way an illusion. . . . For now one sees the work in extension,
that is, looking along its length one sees it in perspective." [50]

 Of course, the fact that an object may appear to change as a viewer
moves around it could be true of almost all sculpture (a characteristic vigor-
ously exploited by artists since Mannerism), yet the repetitive geometric quali-
ties of much Minimalist work cause it to allude to linear perspective even
more specifically than traditional sculpture might. The vertical elements of equal
height in one of Judd's works could be read as a "colonnade," visibly demon-
strating its diminution as it recedes from the viewer, just as the grid structure
of Andre's floor pieces or LeWitt's lattices are immediately susceptible to highly
dramatic perspectival viewing, as the image from an ad for one of LeWitt's
exhibitions proves (fig. 18). [51] Smithson, too, had already emphatically addressed
this condition with his serial objects such as *Algonon #1* and *Plunge* (fig. 19),
which feature rows of geometric structures growing progressively smaller,

FIG. 19

Robert Smithson, *Plunge*, 1966. Painted steel, 10 units,
square surfaces 14 1/2 to 19 in. (36.8 to 48.3 cm)
(units vary in 1/2-in. [1.27 cm] increments). Denver Art
Museum, gift of Kimiko and John Powers

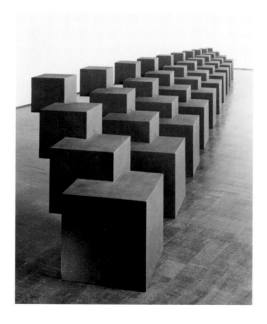

thereby artificially accelerating the diminishment that perspectival viewing would naturally cause.[52]

In addition to these three-dimensional works, the concurrent wave of shaped canvases had revived the topic of perspective in abstract painting, an important discourse to bear in mind because Bochner's photographs would continue to target issues central to that two-dimensional medium. For the most part, perspective did not serve to create space within the limits of these new paintings, but more often the whole canvas could be read as a shape having been seen in perspective, such as Noland's diamond-shaped paintings that often suggest foreshortened rectangles. Ronald Davis capitalized on this impression most directly in parallelogram-shaped paintings (fig. 20), which, to Michael Fried's "amazement," indicated that "after a lapse of a century, rigorous perspective could again become a medium of painting."[53] By situating *H-2* in the context of these developments, we begin to appreciate the complexity of Bochner's engagement with the "natural" perspectival viewing conditions of Minimalist objects, as well as the combination of "natural" and "artificial" perspective touched on by Smithson's receding structures and Davis's parallelogram paintings. Bochner's specific implication of the viewer's perspective, along with that of the camera, prompted him to devote more attention to the phenomenon, which had indefatigably surfaced in all his photographs to date. He clearly recognized that perspective, like seriality, might be thought of as a preconceived schema or "methodology" brought to bear on artistic practice.[54] And as with seriality, Bochner would devote considerable energy to dislodging perspective from its role as art's invisible accomplice, eventually making the system "something to look at, rather than using it to look at something."[55]

FIG. 20
Ronald Davis, *Six-Ninths Red*, 1966. Polyester resin and fiberglass, 72 x 131 1/4 in. (182.9 x 333.34 cm). Collection of Ronald Davis

Perspective

As with his first block pictures, Bochner began *Perspective: One Point (Positive)* (plate 12) by constructing a setup to photograph. In this case, the setup was nothing more than a table covered with strips of black tape forming a perfect grid—the template that had already served as the implicit framework of all his photographs, from the graph-paper diagrams for block constructions to the sixteen panels of *None Tangent*. Bochner then had a photographer shoot the grid from one end of the table, with the camera at an oblique angle to the surface so that nothing else was visible in the viewfinder. In the resultant image, the perpendicular grid on the table became a diagram of one-point

perspective, with orthogonals racing to converge at a central vanishing point beyond the frame. To make two-point perspective, Bochner simply repositioned the camera so that its lens pointed diagonally across the very same taped grid (plate 13).[56] When printing these pictures, he had the contrast adjusted to efface any extraneous detail, leaving only solid black tracks on an uninflected white ground, or vice versa. With this surprisingly simple, low-tech procedure Bochner essentially succeeded in producing totally abstract, schematized photographs of perfect linear perspective. Or almost perfect, that is.

To uncover the nature of those imperfections and the reason why Bochner would even have bothered to make a photograph of a phenomenon so easily drawn, we might compare *Perspective: One Point (Positive)* with its study in pencil and ink on graph paper (plate 62). This simple drawing resembles so many works from the Renaissance onward of receding floor tiles, the basic ground on which figures and scenery might be disposed to create the compelling impression of deep space within the picture. The orthogonals and horizontals of the drawing do not fill the whole sheet as they do in the photograph, but stop as though inscribed within the limits of a rectangular room. Rather than organizing the space around a central vertical alley as in the photograph, Bochner divided the drawing with a centered vertical orthogonal precisely parallel to the sides of the frame. But apart from these obvious differences and the inversion of figure and ground, something still seems dissimilar between Bochner's drawn diagram of one-point perspective and his photograph of the same subject. The sense of precision lent by the drawing's axial symmetry seems somehow unmatched in the photograph, despite its totally schematic, even illustrative, presentation of its subject. Eventually we are surprised to find that distinction owes not only to the photograph's less-emphatic symmetry, but also to the fact that its diagonal lines bend ever so subtly toward the edge of the frame.

As our eyes scan the work, we notice that the orthogonals pull slightly away from the center, even more than their angled trajectory should allow. This effect is most obvious in the two lines that reach the bottom of the image on the right and left side, but actually holds true for all the bands descending from the top of the photograph. By holding a straight rule against the inside edge of any of the orthogonals, we can demonstrate the extent to which the lines curve as they approach the bottom, a phenomenon that grows more exaggerated in the orthogonals closer to the edges of the photograph. A similar effect can be observed in *Perspective: Two Point (Negative)* in which the

diagonal lines slope down toward the bottom of the image, causing a faint swelling at its center.[57] To explain this effect, we might first assume the lines of the original grid were curved, yet in fact, we know them to have been perfectly straight. Rather, the orthogonals' camber owes to the grid having been viewed in perspective through the camera's curving lens.

The fact that verifiably straight lines can sometimes appear curved when perceived by the eye has troubled artists almost since the invention of linear perspective in the Renaissance.[58] At its most basic, this system can be described as a means for projecting three-dimensional forms onto a flat picture plane that functions as a cross section of a visual pyramid, the apex of which is the viewer's eye. However, as Erwin Panofsky has argued, this perspectival construction fails to describe the world as we actually see it, leading him to observe "a fundamental discrepancy between 'reality' and its construction," which, he adds, "is also true, of course, for the entirely analogous operation of the camera." Panofsky then compares "those marginal distortions which are most familiar to us from photography" with those "which also distinguish the perspectivally constructed image from the retinal image."[59] Although Panofsky's scientific explanation for this distortion is not entirely accurate, his observations themselves are still valid and particularly apt with regard to the warping in Bochner's perspective pictures. Panofsky's comparison allows us to imagine the lens almost as a surrogate eye, exaggerating and recording the curvature we might ourselves have experienced more subtly when looking at the original grid from a close, oblique angle.[60] The failure of Bochner's photographs to capture that grid with the strict linearity found in his original drawn study then demonstrates by proxy the disparity Panofsky identifies between the idealized Renaissance "construction" of perspective and the "reality" of how we see.[61]

In their characterization of perspective, Bochner's photographs vacillate curiously between these poles, given that they both reify perspective as an appreciable phenomenon and discredit it as an impossibly idealized construction of space. Since Bochner photographed an exact grid, rather than a perspectival diagram in which taped lines already converged on a vanishing point, his images actually demonstrate perspective "occurring" in real space. Given the medium's indexical claim on "reality," these photographs manage to capture the taped grid seen *in perspective* and therefore propose to verify empirically that system as an observable truth. However, that proposition proves tenuous, since the images also acknowledge perspective as an irrevocably

flawed a priori "construction," unable to describe "reality" as we see it. The gently curving orthogonals markedly deviate from the norm of linear perspective as it would ordinarily be drawn, a departure that signals the system's shortcomings and the futility of attempting to strictly prove its postulates in real, three-dimensional space.[62]

After his first photographs of one- and two-point perspective, Bochner embarked on a series of works experimenting with the interplay between these two systems. In *Perspective Insert (Two in One)* (plate 14), Bochner inset a panel cut from his photograph of two-point perspective into his photograph of one-point perspective. The parallelogram shape of the cut-out alludes to an overhead view of a rectangle, the sides of which converge evenly based on the lines in the two-point perspective grid. Although Bochner attempted to center and align the panel within the one-point perspective background, its sides do not track properly in relation to the orthogonals in the larger image. The two systems could not be perfectly reconciled, although they picture the same original space, and we are left with two planes that appear to recede at different angles and rates.[63] For several other perspective pieces, Bochner made a Photostat of *One Point Perspective (Negative)*, which he crumpled and then rephotographed, so that the perspectival grid became an indeterminate, undulating terrain (plates 20, 21).[64] In these works, pictorial space is a function not only of the diminishing orthogonals, but also of the highlights and shadows occurring naturally on the crumpled Photostat: the wrinkled expanse in the final flat photograph is then a record of both the original perspective view of the taped grid *and* the irregular surface of the crumpled copy. In *Perspective Insert (Collapsed Center)* (plate 19) Bochner overlaid one of these crumpled images on its source to create a window within the picture window looking onto an entirely incongruous space.[65]

In the works that followed, Bochner reprised the silhouette technique of *H-2* (plate 3), creating several more compelling trompe l'oeil objects. One, *Convex Perspective* (plate 15), was made by combining the methods behind *H-2* and the first perspective photographs. Bochner began by applying a perfect taped grid to a convex corner in his studio where two walls met at 90 degree angles. He then photographed that grid with the camera aimed directly at the apex of the corner, so the perspective in the image was naturally observed, rather than forced diagrammatically. Finally, he mounted the work on Masonite and silhouetted around the edges, so that the photograph—still flat—appears to protrude dramatically from the wall. In other works, he

silhouetted photographs of crumpled perspective Photostats, which on first glance have the appearance of actual folds when they are, in fact, totally smooth (plate 24). This series ends with *Surface Dis/Tension* (plate 25), the culmination of his work with perspective, silhouetting, and composite photography. Bochner created the image by soaking a photograph of one-point perspective in water until he could remove the top layer of silver salts from the dissolved paper support. After carefully peeling off this fine surface, Bochner hung it on a line to dry, causing numerous wrinkles and puckers. He then rephotographed this flayed skin of his earlier photograph and printed the image in both positive and negative on the same piece of paper. By slightly shifting the position of the paper in the middle of the two-part printing process, Bochner achieved the look of high-contrast solarization to give the surface its textured appearance.[66]

Of all Bochner's photographs to date, none so comprehensively summarized the concerns he had raised thus far. As in his earlier perspective photographs, we find him grappling with that system as both a preconceived theory of art making and a perceptually verifiable phenomenon that the picture records. Yet, in literally pulling the photograph's impossibly slight sliver of silver from its backing, his method achieved a new level of complexity. More than in any of his earlier segmented or silhouetted works, Bochner here treated the very membrane of the image as a material substance, open to physical manipulations almost completely independent of the original referent or its paper support. The final photograph is thus less a record of the initial taped grid's spatial recession than an index of the shrinking and disfiguration of the picture's previous incarnation, particularly given that the shape of the object precisely matches the contours created as the disembodied image dried. The orthogonals themselves no longer map the plane on which they originally sat but rather traverse the crinkled terrain of the actual photograph in which they were first captured. Here again the problem of a literalist photography reemerged, because Bochner's handling of the photograph was so direct and self-reflexive that it seems almost nonrepresentational, referring to nothing beyond itself.[67] As usual, however, photography's inevitable filter foils any absolute claim to literalism, since we quickly realize that we are not looking at a furrowed surface but at a perfectly smooth one. With this work, Bochner clearly reveled in rendering that tension more pronounced than ever before, and he reached a bravura endpoint in his physical treatment of the photograph—but not without introducing a whole new wrinkle.

FIG. 21

Barry Le Va, *4 Sections: Placed Parallel*, 1967.
Aluminum and felt on floor, 30 x 65 ft (9.1 x 19.8 m)

Through the Picture Window

As early as his first crumpled perspectives, Bochner had already begun to abrade the rigorous geometry of Minimalism's weighty inheritance. In these pieces, the rigid linearity of his first photographs yielded to softer edges and more open systems, less strictly predetermined and increasingly subject to chance. This transition can be aligned with the emergence of a number of artists, including Keith Sonnier, Richard Serra, and Barry Le Va (fig. 21), all of whom confronted Minimalism's severity in soft and irregular sculpture that came to be grouped under the rubric of "Post-Minimalism" or "Anti Form."[68] In particular, Bochner's close relationship with Eva Hesse deserves serious consideration, because she consistently explored variable processes, as well as the sensuous effects of surface and texture. Her piece *Untitled, or Not Yet* (fig. 22) comprises swollen bags of fishnet—a gridded web warped as in Bochner's later *Crumples*.[69] Bruce Nauman, who showed alongside Hesse in the 1966 exhibition *Eccentric Abstraction*, provides another compelling point of comparison, since, like Bochner, he had begun making photographs that year. Bochner was particularly impressed by *Flour Arrangements* (fig. 23), a group of seven pictures featuring abstract mounds of baking flour strewn in piles that Nauman rearranged on his studio floor every day for a month. This process displays obvious affinities with the changing block progression of *36 Photographs* (plate 1); however, unlike Bochner, Nauman's use of materials was more gestural and improvisatory, completely ungoverned by precise formulae.[70]

FIG. 22

Eva Hesse, *Untitled, or Not Yet*, 1966. Nine dyed fish-net bags with clear polyethylene, paper, sand, and cotton string, 41 5/8 x 17 3/4 in. (105.8 x 45.1 cm) overall. San Francisco Museum of Modern Art, purchase through gift of Mrs. Paul L. Wattis

FIG. 23

Bruce Nauman, *Flour Arrangements*, 1966. Seven color photographs, heights variable, width approx. 24 in. (61 cm) Collection Hallen für neue Kunst, Schaffhausen, Switzerland

Following *Surface Dis/Tension* (plate 25), Bochner also adopted more organic and impermanent materials and processes. Armed with an inexpensive Polaroid camera, he took to the roof of his studio, where he shot two final images of grids, which serve as both a pendant to his perspective work and a prologue to what would follow. For one photo, Bochner sketched a grid in mineral oil, while for the second he treated his subject with hasty ribbons of shaving cream (plates 26, 27). Although both of these works build on his long-standing use of the same graphic device, their unstudied appearance heralds a fresh confidence to experiment before the camera's watchful eye. This freedom was encouraged by the Polaroid's claim to immediacy, which aptly complements Bochner's choice of evanescent domestic products, adding a wry, almost absurd inflection to the Modernist grid. Furthermore, because the Polaroid produces no negative, Bochner was prohibited from reworking or reprinting images, as had been his custom.[71] A photograph such as *Viscosity (Mineral Oil)* (plate 26) then makes a perfect foil for its immediate predecessor, *Surface Dis/Tension*, since the later work's irregularity owes to its initial subject, while the earlier warping depended not on the original grid, but on the manipulation of an intermediary print. Between these works of ostensibly similar "subject matter" we can observe Bochner quite specifically questioning the point in the photographic process at which an image achieves its form—whether before or after the shutter's release.

Bochner pushed this problem further in a series of twelve photographs executed under the auspices of E.A.T. (Experiments in Art and Technology), an organization dedicated to providing artists access to a broad range of technologies.[72] With E.A.T.'s funding, Bochner hired a professional product photographer, whom he asked to do nothing more than make the most beautiful pictures possible of Vaseline and shaving cream, to be titled *Transparent and Opaque* (plate 32). For the "transparent" part of the work, Bochner applied Vaseline to a plate of glass with short strokes of his finger, recalling the surfaces of the monochrome paintings he made on his arrival to New York (fig. 24).[73] Next, he had the photographer shoot the Vaseline under strong raking light, bathing the otherwise clear substance first neutrally, then in lustrous gold and amethyst, deep vermilion, and cotton-candy pink. They repeated the process three times with different lights trained on the "opaque" shaving cream, which Bochner squirted over the glass in generous, unruly squiggles. After the first three shaving cream pictures, Bochner sprinkled scarlet iodine on the creamy surface, a flourish he had applied once before to the Vaseline. He

FIG. 24

Mel Bochner, *Untitled*, 1964. Oil on Masonite, 12 x 12 in. (30.5 x 30.5 cm). Collection of the artist

then whipped the cream into a luscious pink concoction and made two photographs complementing his picture of the pink-toned petroleum jelly.[74]

In *Transparent and Opaque*, the colorless Vaseline and white foam function as neutral grounds on which light proves itself the central agent in the photographic process. The greasy tracks and soft, frothy folds act as nothing more than snares for catching an ostentation of color, highlight, shadow, and thereby texture. It seems fitting, then, that these pictures, along with the preceding Polaroids, were the first works in which Bochner used genuine color photography, rather than simply lacquering or dyeing black-and-white prints as he had done previously in a number of colored perspective pieces.[75] Yet instead of avoiding dyeing altogether, he subtly toys with the newly adopted color technology by selectively transferring the tinting process from the final print to the substances depicted within. For example, if we compare the pink-lit Vaseline and iodine-dyed shaving cream pictures, we find that, despite their analogous hues, the very locus of their color differs between a physical substance actually made rosy and the transformative effect of immaterial light. Both prints are pink, of course, but the distinction between their chromatic formation, like the contrast between the deterioration in *Surface Dis/Tension* and *Viscosity (Mineral Oil)*, foregrounds the multiple levels of visual information that contribute to the final photographic print. Bochner pursued this question further in two pictures of exactly the same piece of crumpled, clear plastic film photographed with different polarizing filters (plates 39, 40).[76] In a stroke of chameleon cunning, one *Polarized Light* is warm red and ocher, while the other image captures the identical surface in purple and aquamarine. These photographs, along with those of shaving cream and Vaseline, show Bochner working to disassociate color from a fixed material vehicle, an effort akin to his earlier interest in stripping a visual phenomenon, such as perspective, from the solid forms that would ordinarily demonstrate its postulates.[77] And once more, photography provided an incomparable site for his project, especially given the medium's procedural dependence on light, color's necessary envoy.

But what of "opacity" and "transparency," the very properties to which Bochner's title refers? How, we may wonder, did his tightly controlled photographic inquiry leap from an examination of perspective to gaudy, glistening surfaces with nothing more than two degraded grids to serve as stepping stones? For an answer, we might turn to another series of three Polaroid works also executed hastily on Bochner's roof. The first, *Transparent Plane #1* (plate 28), consists of a pair of photographs, one depicting a glass plane streaked with

water propped on small black cubes, and another showing a tightly cropped close-up of the hazy surface. The second work, *Transparent Plane #2* (plate 29), roughly repeats those shots with the addition of dribbled iodine, while *Transparent Plane #3* (plate 30) consists of a single image of two blurry bubbles on a dark black ground. Initially, these beguiling slapdash images appear mere rooftop doodles, quick sketches in anticipation of Bochner's visit to the professional photographer. After greater consideration, something more seems at stake in these pictures and in Bochner's sustained attention to "transparency," a central metaphor in the history of Western art since Alberti likened the surface of a perspectively constructed picture to a transparent plane of glass.[78]

According to the formalist account of Modernism dominant when Bochner began photography, Alberti's model of the picture "window" persisted until the nineteenth century, when artists began to shift their attention from compelling illusion to the physical properties of the surface as such. Whether liberating brushstrokes from the burden of depiction or drawing attention to the framing edge, Modernist painting flattened the fictive space that once expanded beyond the canvas. This shift was central to the formalist criticism of the sixties, which approached a painting itself as a material sign—an "opaque" object—rather than as a "transparent" window onto another world. Within the context of this transition Bochner's Polaroid "sketches" suddenly appear more pointed than offhand. Turning again to *Transparent Plane #1*, we immediately recognize the "transparent plane" of glass in the image, but Bochner's title implies a double meaning, asking us also to see the photograph itself as a "transparent plane." This is quite easy in one of the two Polaroids, because we see through the photograph's "window" onto the rooftop where the glass plane sits. Yet in the close-up, the glass's hazy surface bars our apprehension of any pictorial space, ironically rendering both the depicted surface and the actual photograph less transparent than opaque.

With *Transparent Plane* in mind, we can now piece together the link between Bochner's perspective pictures and the seemingly unrelated images of shaving cream and Vaseline.[79] All of Bochner's earliest photographs had, to a certain extent, been necessarily spatial, but only in *Perspective: One Point (Positive)* and the following pictures did he begin to confront directly that unexpected consequence of his turn to photography. With a simple camera angle, Bochner transformed the perpendicular grid from a twentieth-century device used for flattening pictorial space into the very perspectival tiles that lent depth to the Renaissance picture. Through this almost diagrammatic perspective,

the photographic frame specifically approximated the transparent plane of painting, leading Bochner to transgress more freely into the forbidden realm of spatial illusionism questioned by Modernist painting and indicted by the Minimalist object. "Opacity" and "transparency" then surfaced as key terms in Bochner's broader photographic experiment, because they encapsulated the opposition between the "opaque" work to which he responded and the more "transparent" physical and conceptual space that photography revealed.

Yet as usual, the physical setup of Bochner's photographs hindered as much as it aided in evoking the predetermined linguistic concept. Although the Vaseline is clear, we cannot see much beyond its supposedly "transparent" surface, which does not yield to our sight but blocks it with a bright reflection. Conversely, despite the "opacity" of the shaving cream, the picture window itself still functions transparently enough to suggest distance between the surfaces of the cream and the photographic print. As with seriality, perspective, and color, Bochner may not have initially understood that "opacity" and "transparency" could be visually distilled only to a point. Inevitably, the reality of the physical setup intervened to conflate the very terms that the photographs had been intended to distinguish. So much the better, of course, because Bochner's photography had come to thrive on this friction between a schema and its picture, finding in that tension both wry humor and philosophical advantage.

Measurements

In the fall of 1968, Bochner embarked on what would be his final foray into photography. That September he was chosen by E.A.T. and the Singer Company, a New Jersey sewing machine manufacturer, to participate in an artist-in-residence program at the Singer Central Laboratories in Denville, New Jersey. Bochner was the first participant in this fledgling venture that placed artists in commercial environments where they might collaborate with scientists and technicians. He had applied to create "sculpture involving photographic processes" and was handpicked by the Singer Company to work with Edwin Webb, an engineer with a background in physics and "information analysis techniques."[80] Once a week for roughly four months, Bochner would visit the lab where he had access to scientific and photographic equipment, as well as to a number of employees with whom he could discuss his art. According to his E.A.T. proposal, Bochner had hoped to work on "numerical photograph translations, set determinations for serial projects and possibilities involving photographing from computers."[81] However, owing to technical

FIG. 25
Mel Bochner, Cover from *The Singer Notes*, 1968.
Marker on graph paper, 11 x 8 1/2 in. (27.9 x 21.6 cm).
Collection of the artist

FIG. 26
Mel Bochner, Page from *The Singer Notes*, 1968.
Ballpoint pen on paper, 11 x 8 1/2 in. (27.9 x 21.6 cm).
Collection of the artist

difficulties and Bochner's changing priorities, none of these projects was
ever realized.

Instead, much of Bochner's work at Singer seems to have been devoted
to wide-ranging conversation with the staff. At the end of each visit to the
lab, Bochner would collect the notes and drawings he and the scientists had
made throughout the day, later compiling the scraps into a work titled *The
Singer Notes* (figs. 25, 26, and plate 75).[82] Amid this notebook's flurry of ideas
from three-dimensional color wheels to computers, we find Bochner reflect-
ing on some of his earliest photography, whether in comments on seriality or
sketches, including blocks, grids, and even a construction from his very first
photograph. *Roll* (plate 41), one of the few photographic works actually com-
pleted at Singer, clearly recalls these beginnings in its initial setup of four
cubes positioned on a grid. Bochner aimed a TV camera at this setup and
fed the picture to a closed-circuit monitor, which he photographed while
modulating the vertical hold and incoming signal. The blocks on the screen var-
ied from nervous flickers to skewed smears of undifferentiated pixels, recall-
ing again the work of Marey and Eakins (see fig. 12).[83] In one image we see the

bottom and top of the blocks ostensibly trade places, as the bottoms "roll" up to the top of the screen and the tops push in from the lower edge (fig. 27). The line across the center of the photograph suggests the split between two images in a Muybridge work or the vertically stacked cells of a motion picture. Yet unlike a Muybridge or cinematic film, in which a fraction of a second distinguishes two adjacent cells, the "real," "continuous" time of closed-circuit TV insists on the temporal contiguity of Bochner's fractured image—essentially serializing a single moment in time. These temporal and spatial gymnastics reprise central concerns from Bochner's earliest photographs, while the TV acts as mediating "screen," blurring not only the blocks but also the layers of information contributing to the final photographic print.

In addition to revisiting some of these long-standing concerns during his time at Singer, Bochner also stumbled on a discovery that would lead him to an entirely new body of work. Recalling his discussions with the scientists Bochner remarked, "Most of the conversations emphasized how to communicate experience and information, and communication always came around to quantification, and that's how I got to the measurements."[84] These "measurements" first appeared in a group of five unassuming black-and-white photographs, in which Bochner marked off a distance in small black Letraset numbers (plates 42–46). For example, one picture captures a cropped, oblique view of a scuffed door meeting a gray expanse of linoleum tiling. Running along a seam in the tiles, two short black pieces of tape mark off a distance between the door and an indeterminate point on the floor, directly in the middle of which hovers the mark "12"." Another photograph pictures "10"" spanning from an aerosol canister to the molding of a door frame, while a third measures "12"" running from the top of a door down its edge. The remaining two photographs mark off "36"" along the floor and "12"" from a wall molding to a piece of black cloth.

If these descriptions sound somewhat vague, it is because most of the measurements themselves, despite the apparent precision of their distances, bear an ambiguous relationship to the terrain they chart. The "36"" measurement, for instance, starts at a joint between the wall and the floor and then stops for no particular reason after running its predetermined course. Similarly, the "12"" mark on the side of the door starts at the door's upper edge and stops before reaching any other physical "landmark," and we may wonder whether the width of the taped endpoints is included within the measurement itself.[85] Ordinarily, we measure the distance between things—be

FIG. 27
Mel Bochner, Detail from *Roll*, 1968. Gelatin silver
print, 20 x 24 in. (50.8 x 61 cm).
Whitney Museum of American Art, New York

it two cities or objects in a room—but Bochner's measurements most often seem not to mark the distance between meaningful physical points. This "free-floating" quality makes them seem almost absurd, because they are robbed of the function they would usually perform.

Yet rather than simply comic, the dissociation between the measurement and its ground provides an incisive point of entry into Bochner's thinking. As with so many of his prior photographs, here he was intent on posing an a priori spatial concept (the measurement) in relation to the physical world it would ordinarily describe. By using "round" measurements such as a foot or a yard (not 13") without specific regard to their ground, Bochner points out how we perceive space according to a set of culturally constructed standards. These measurements then seem more like preconceived, linguistically defined distances projected onto a space, rather than deriving from that space or being indexically tied to it. Had the measurements more specifically mapped meaningful distances, such as the full height of the door or the exact space between things on the floor, we might not have grasped the more abstract "idea" of measurement Bochner hoped to convey. But even he must have been surprised by the level of "abstraction" suggested by the scale shift between the distances in the room and those in the print.

Only after looking at the 8 x 10 photographs was Bochner struck that the measurements indicated within the image bore absolutely no relationship to the distance they occupied on the print. At first this may seem like an obvious point, because a small photograph might easily picture an enormous building, while a large print could feature a minuscule object. Yet the essential scalelessness of photography grows startlingly explicit when a measurement is indicated on a plane parallel to the picture's surface, as in the case of the spray can photograph in which ten inches occupies less than five. To confirm Bochner's explicit interest in this problem, we need only turn to the two photographs that he made immediately following his first group of measurements (plates 47, 48). Bochner began by marking a distance of one foot on a blank wall perpendicular to the camera's line of sight. Then he made photographs of his hand and profile flat against the "12"" mark on the wall. The works' titles, *Actual Size (Face)* and *Actual Size (Hand)*, imply no scale shift between Bochner's body and its representation. To make good on the titles' promise that the images be actual size, Bochner needed only instruct the photo lab to print the final pictures so that the "12"" mark in the image occupied exactly twelve inches on the paper. Bochner later recalled that in making

the pictures "actual size," he had hoped the photograph might somehow invisibly summon his body parts without any mediation, so that "nothing would be left other than the face and the hand, and the photographs would essentially just disappear."[86] And then they did.

"Photography Cannot Record Abstract Ideas"

After these pictures of his face and hand, Bochner abandoned photography, but not its lessons.[87] His plan simply to bring forth his body as though unmediated served as a cunning last grab at a one-to-one relationship between the photograph and its referent—the unattainable literalism dogging nearly all his experiments in the medium. But on inspecting these works, Bochner must have realized that the measurement—not his body—was the only thing literally present. Twelve inches was twelve inches, both before and after the camera intervened. Shortly after leaving the Singer Lab, Bochner began making measurements in his studio on a variety of grounds: paper, boxes, card-

FIG. 28
Mel Bochner, *Measurement: Room*, 1969.
Tape and Letraset on wall. Installation, Galerie Heiner Friedrich, Munich, 1969. Museum of Modern Art, New York

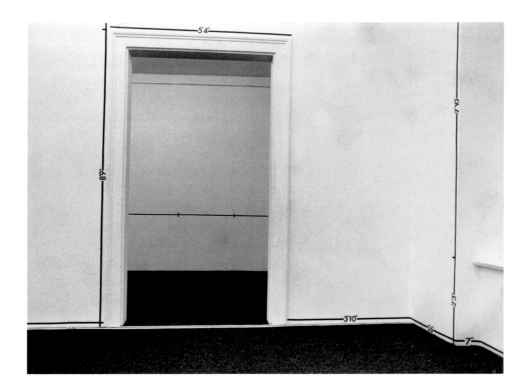

FIG. 29

Mel Bochner, *Meditation on the Theorem of Pythagoras*,
1972. Hazelnuts and chalk on floor, approx. 17 x 16 in.
(518.5 x 488 cm). Installation, Galleria Marilena Bonomo,
Bari, 1972. Allen Memorial Art Museum, Oberlin, Ohio

board, and, in his most well-known installations, the wall itself (fig. 28).[88]
He considered these new measurements works in themselves, rather than simply setups for photographs. As in the preceding photographs, the Letraset distances mapped an a priori concept on a physical space, but now without the filter of the photographic print. Bochner later recalled that these new measurements provided a way for him to work "literally and pictorially at the same time," a comment that points both to the literal, indexical relationship of a measurement to its ground and the pictorial, representational status of the numeric distance as a linguistic sign.[89]

Bochner pursued this collapse of the literal and pictorial in nearly all of his art during the next few years, including works such as the *Theory of Painting* (1969–70) and *Meditation on the Theorem of Pythagoras* (fig. 29), both of which posit a conceptual schema directly against its physical manifestation. Focusing on this interaction between a concept and its implementation, Rosalind Krauss eloquently described Bochner's work "as a consistent attempt to map the linguistic fact onto the perceptual one—not to show the insubstantiality of the one as opposed to the materiality of the other, but to demonstrate the necessity in experience of their mutual fruition."[90] Although Krauss's comment is certainly apt, she does not consider how Bochner may have arrived at such a position. For if by 1969 that interplay had come to represent the primary goal of his work, we must recognize that this had not always been the case.

In contrast, we should recall that Bochner initially approached the "pictorial" with great suspicion until the camera softened his reticence. Before making *36 Photographs and 12 Diagrams* (plate 1), Bochner was caught in a struggle between his interest in seriality and the physical presence of his block constructions, which failed to express their underlying mathematical schema as clearly as he had hoped. Photography offered Bochner a way to avoid obscuring his serial permutations in distracting sculptural production, but the medium's price was high. In exchange for aid in emphasizing a preconceived schema, the camera imposed a level of pictorial mediation that was anathema at the peak moment of Minimalism's anti-illusionistic mandate. As we have seen, Bochner vainly attempted to transfer that literalist imperative to his photographs, but their recalcitrance compelled him to accept a degree of distancing representation, which the camera invariably slipped into the final print. Photography then forced him to confront the pictorial, whether he wanted to or not. With its claim to an observed reality circumscribed within two dimensions, the medium provided Bochner a space at once indexically tied to our

world and representationally removed from it. So, despite his original plans, photography proved less adept at separating theoretical systems from their physical application than testing the complex interaction between the two.

Although Bochner never returned to photography, he could not resist bidding farewell to his indefatigable partner in a print edition titled *Misunderstandings (A Theory of Photography)* (plate 49). That work was published in 1969 under the auspices of Marian Goodman's Multiples Gallery as part of *Artists and Photographs*, a box including contributions by Nauman, Smithson, Graham, Rauschenberg, Warhol, Dibbets, and Kosuth, among others.[91] Bochner's *Misunderstandings* consisted of a manila envelope containing nine photo-offset prints of handwritten quotations (three of which he invented) and a negative reproduction of the original Polaroid of *Actual Size (Hand)* (plate 48). The quotations range in source from Taine to Marcel Duchamp to Mao Tse-Tung, and each is as suspect in its reasoning as in its authenticity.[92] One in particular seems to have especially captivated Bochner, because he later reproduced it as the subject of an individual photographic print (plate 50). The text, attributed to *Encyclopedia Britannica*, reads, "PHOTOGRAPHY CANNOT RECORD ABSTRACT IDEAS," and we can imagine Bochner winking at the patent absurdity of this photograph, itself quite obviously recording an "abstract idea," just as his pictures of color, perspective,

FIG. 30
Mel Bochner, *Language Is Not Transparent*, 1970.
Chalk and paint on wall, 72 x 48 in. (182.9 x 121.9 cm).
Installation, Dwan Gallery, New York, 1970

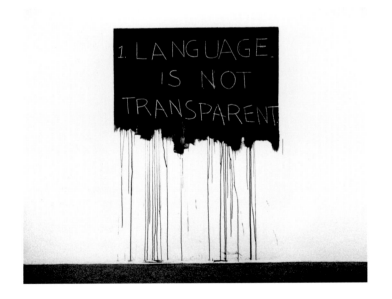

and measurement had before. But perhaps photography shares the last laugh, because after all, if the camera had taught Bochner anything, it was precisely the difficulty of communicating a purely abstract idea.

And what could have been a more poignant send-off? Whether in the warped orthogonals of his perspective pictures, the scale shifts of his first measurements, the ambiguous opacity of a supposedly transparent plane, or the ever-evasive schema divorced of its support, Bochner's photographic foray was riddled with misunderstandings that few young artists would have the courage to confront, let alone the ability to see. Without those misunderstandings and the deep understanding they bred, we could imagine that Bochner might have followed an altogether different path, pursuing linguistic schemas with less care for their vehicle. What if, we might wonder, his photographs had obligingly proffered their preconceived systems as seamlessly as he had originally imagined? Had he not repeatedly tugged at that problem, would he still have been led to argue that "Language Is Not Transparent" (fig. 30) or that "No Thought Exists Without a Sustaining Support"? Although Bochner made both these claims away from photography, their message draws directly on the profound impact of a medium that acted more as his teacher than as his tool.

Notes

1 Dwan's visit would have been extremely important to Bochner, because her galleries in New York and Los Angeles had shown a number of artists whose work he particularly identified with and admired. In 1966 alone, she staged the important group exhibition *10*, as well as solo shows of Carl Andre (LA), Sol LeWitt (NY), Robert Morris (LA) and Robert Smithson (NY).

2 Mel Bochner, "Seriality and Photography" in *Mel Bochner*, exh. cat. (Rio de Janeiro: Centro de Arte Hélio Oiticica, 1999), 54. For an example of this multipart, sculptural approach to seriality, we might consider Robert Smithson's *Plunge* and *Alogon #2*, each of which comprised ten units of identical shape, which varied incrementally in height. Smithson included both of these works in his December 1966 exhibition at Dwan.

3 Mel Bochner, "The Serial Attitude," *Artforum* 6 (December 1967): 28–33. In this article, Bochner was careful to distinguish between artists interested in "seriality" and those who simply worked "in series," by making different versions of a theme (as Monet

did in his haystack or Japanese bridge paintings, for example). According to Bochner, Kelly's multipart canvases, Rauschenberg's *Seven White Panels*, and Warhol's multipanel silk-screens all depended on a repeating "modular," not technically "serial," organization. Bochner defined this "modular" approach as "the repetition of a standard unit"—whereas more fully serial works demonstrate a predetermined change between units. Yet despite this subtle difference, these artists' renunciation of composition in favor of a predetermined system of order tied them to later serial work. As for Stella, Bochner specifically cites the black paintings, such as *Die Fahne Hoch* (1959), as relying on "rotational procedures in the organization of quadrants."

The text was published concurrently with the thematically related exhibition *Art in Series*, organized by Elayne Varian with Bochner's help for the Finch College Museum of Art. The exhibition, which ran from November 1967 to January 1968, included Bochner's *16 Isomorphs* (1967), to which we will return, as well as pieces by Ellsworth Kelly,

Judd, Andre, Flavin, Smithson, and Eva Hesse, among others.

4 In Judd's early work, he relied primarily on symmetry and modular sequences as a way of avoiding composition, which, for example, he described in the work of Mondrian as "the idea of taking some little part down here to adjust it to balance some big part up there." Donald Judd, "An Interview With Donald Judd," interview by John Coplans, *Artforum* 9 (June 1971): 47.

5 Ibid., 49. Judd's earliest relief in this mode actually dates to 1964, but he did not seriously pursue these ideas until 1965. In addition to the Fibonacci series, Judd also employed the "inverse natural number series: one, minus a half, plus a third, a fourth, a fifth, etc." as a means for creating pieces that looked more asymmetrical and complex than his modular stacks, while still eschewing subjective composition.

6 According to Bochner, the work's terse statement of its schema is "fundamentally parsimonious," as befits its dedication to Ockham, the fourteenth-century author of "the law of parsimony." See Mel Bochner, "The Serial Attitude," 33. In addition to Bochner, a range of artists, including LeWitt and Kosuth, were deeply indebted to Flavin's example. We should note that Bochner was impressed not only by Flavin's work with seriality, but also by his appropriation of the light fixture as a material for sculpture: "Flavin takes something that is supposed to aid you in looking at something and makes it something to be looked at." (Mel Bochner in conversation with the author, 1999). This strategy later informed Bochner's interest in isolating and examining the preconceived theories behind artistic production, such as perspective and measurement, among others.

7 LeWitt's interest in seriality may actually have preceded Judd's by several years, as evidenced by his Muybridge-inspired works (to which we will return), which he began as early as 1962. Nevertheless, these serial ideas did not become entirely explicit until *Serial Project #1 (ABCD)* of 1966. One quadrant of the work holds narrow solid forms within wider open ones; another reverses that arrangement; and the remaining two are devoted to solid within solid, and open within open. Each of the four quadrants then charts the interaction of the wider and narrower volumes as they vary progressively among four possible heights.

8 Sol LeWitt, "Serial Project #1, 1966," *Aspen* 5–6 (fall–winter 1966–67).

9 Sol LeWitt, "Paragraphs On Conceptual Art," *Artforum* 5 (June 1967): 80. A detail of Bochner's *36 Photographs and 12 Drawings* was illustrated with the article, clearly indicating that Bochner's work was considered within the context of this new "Conceptual art."

10 James Meyer, "The Genealogy of Minimalism: Carl Andre, Dan Flavin, Donald Judd, Sol LeWitt, and Robert Morris" (Ph.D. diss., Johns Hopkins University, 1995): 284. Bochner himself wrote, "The fascination with seriality and modular form (which continues, disguised, in the work of many artists) made it possible, at one point, to clarify and distinguish the processes involved in the realization of the work of art." Mel Bochner, "Excerpts from Speculation," *Artforum* 8, (May 1970): 71.

11 Some Minimalist art had already been labeled "conceptual," because it was thought to be so plain, so visually "minimal," as to be easily "described in words," but that attribute was more a by-product of its formal simplicity than a specific goal to substitute the linguistic for the physical. For example, James Meyer describes this response as characteristic criticism of Andre's *Lever* and *Equivalents*, works from 1966 comprising bricks in simple geometric arrangements on the floor. See Meyer, "The Genealogy of Minimalism," 84, 261–65.

12 Meyer writes, "[the work] should not require—it should indeed avoid—the supplement of a linguistic analogy. . . . As Judd understood too well, LeWitt, introducing language into the realm of abstraction, confounded the ontological self-sufficiency of the empirico-formalist object of late modernism." Meyer, "The Genealogy of Minimalism," 282–83. For Judd, the virtue of serial systems, such as the Fibonacci sequence, lay both in the viewer's recognition that the work was not compositional, and in the utter improbability that the system would become the primary interest of the work. Judd remarked, "No one other than a mathematician is going to know what that [Fibonacci] series really is. You don't walk up to it and understand how it is working, but I think you do understand that there is a scheme there and that it doesn't look as if it is just done part by part visually. . . . The point is that the series doesn't mean anything to me as mathematics." Donald Judd, "Interview with Donald Judd," 47–49.

13 Bochner had exhibited other drawings in the context of *Working Drawings And Other Visible Things On Paper Not Necessarily Meant To Be Viewed As*

Art, an installation he created in December 1966 at the School of Visual Arts, New York. That piece consists of four pedestals supporting identical loose-leaf binders, which each contain one hundred photocopies of drawings and diagrams by artists, including Judd, Hesse, LeWitt, and Flavin, as well as pages by anonymous scientists and engineers. This work's stress on the concepts or processes undergirding artistic production ally it with Bochner's changing block constructions. Nevertheless, *Working Drawings* differs in emphasis, because it does not directly pose those processes against the objects that they might engender. For more on this work, which has been hailed by Benjamin Buchloh as the first "truly conceptual exhibition," see Benjamin H. D. Buchloh, "Conceptual Art 1962–1969: From the Aesthetic of Administration to the Critique of Institutions," republished in *October: The Second Decade* (Cambridge: The MIT Press, October Books, 1997), 121–23, and James Meyer, "The Second Degree: *Working Drawings And Other Visible Things On Paper Not Necessarily Meant To Be Viewed As Art*," in Richard Field, *Mel Bochner: Thought Made Visible 1966–1973*, exh. cat. (New Haven: Yale University Art Gallery, 1995), 95–106.

14 Mel Bochner in conversation with the author, 1999.

15 This bias against the medium was clearly evident in most venues for contemporary art. The overwhelming majority of New York galleries showing painting and sculpture would not have exhibited photography in the mid-sixties. However, it is important to note that throughout the early to mid-sixties, even before the later proliferation of "photorealistic" art, photography did enjoy new attention within the context of contemporary painting. For example, from 1964 to 1965, seven venues hosted the exhibition *The Painter and the Photograph*, which presented a historical survey of photography's impact on painting. See Van Deren Coke, *The Painter and the Photograph*, exh. cat. (Albuquerque: The University of New Mexico Press, 1964). In addition, the Guggenheim Museum organized *The Photographic Image*, a 1966 exhibition of seven contemporary painters, including Warhol and Rauschenberg, all of whom used photography as source material. See Lawrence Alloway, *The Photographic Image*, exh. cat. (New York: The Solomon R. Guggenheim Museum, 1966). Yet, for the most part, critics and curators still privileged painting. As Robert Pincus-Witten noted in his review of the Guggenheim show, Alloway insisted

on subsuming photography within painting, rather than accepting it as an equal partner in the work he displayed: "Mr. Alloway emphasizes, rather, the redigesting of the photograph into the work of art, thereby achieving a selection which in great measure obviates the presentation of the initial document." Robert Pincus-Witten, "The Photographic Image," *Artforum* 7 (March 1966): 47.

16 *Artforum*, which became the most important magazine for new art by the mid- to late sixties, sequestered the majority of its photography coverage in a separate monthly column throughout much of the decade. Though the magazine might have been deemed progressive for dedicating a column to the medium, the photography coverage was generally far more conservative than the other editorial content, and its separate and limited discussion would have signaled its lower status in comparison with painting and sculpture.

As for Greenberg, still a towering critical presence in the mid-sixties, he proclaimed in 1964: "The art in photography is literary art before it is anything else. . . . And as in prose, 'form' in photography is reluctant to become 'content'." Clement Greenberg, "Four Photographers," in *Clement Greenberg, the Collected Essays and Criticism*, ed. John O'Brian (Chicago: University of Chicago Press, 1993), 4:183. In emphasizing photography's "anecdotal," narrative role, Greenberg diminished its capacity for exclusively formal interest and separated the medium from other "visual" arts. By tethering photography to the burden of depiction, he denied it the very autonomy he praised in what he perceived to be the best Modernist painting. However, Greenberg did leave open the possibility that an abstract photograph could be as good as an abstract painting, though he claimed never to have seen one and likened abstract photography to a kind of self-deception wherein one is merely "painting with light on a light-sensitive surface, and that's kind of fooling." Clement Greenberg, "Night Six," lecture delivered 15 April 1971 as part of *The Bennington College Seminars*, reprinted in Clement Greenberg, *Homemade Esthetics* (New York: Oxford University Press, 1999), 155.

17 Donald Judd, "Specific Objects," *Arts Yearbook* 8 (1951), reprinted in *Donald Judd Complete Writings: 1959–1975* (Halifax: Press of the Nova Scotia College of Art and Design; New York University Press, 1975), 184. Judd wrote, "Almost all paintings are

spatial in one way or another. . . . Two colors on the same surface almost always lie on different depths." Even a monochrome canvas, he bemoaned, "is almost always both flat and infinitely spatial." See Donald Judd, "Specific Objects," 182.

18 Although Judd did not specifically address photography in his writings, by the mid-sixties Carl Andre voiced strong reservations about the medium's ability to convey the tactile experience central to his sculpture. For more on Andre's remarks on photography and the relationship of photography to Minimalist objects, see Alex Potts, "The Minimalist Object and the Photographic Image," in *Sculpture and Photography*, ed. Geraldine Johnson (New York: Cambridge University Press, 1998), 192–95.

19 Ruscha commented on Evans's importance to his early work in a speech delivered at the Getty Center, Los Angeles, 17 July 1998. Bochner was so impressed by Evans's work that he purchased two of his photographs from a small show at New York's Robert Schoelkopf Gallery in 1965. One of those photographs, *Penny Picture Display, Birmingham* (1936), would have interested Bochner not only for its use of language, but also for the serial deployment of small portrait pictures filling the frame in a grid. That image and others of shop windows were particularly important to Bochner, as evidenced in *New York Windows*, a short 16-mm film he made collaboratively with Robert Moskowitz in 1966. For more on *New York Windows* see Elisabeth Sussman's essay in this catalogue and Sasha Newman, "The Photo Pieces," 114–19.

20 Ed Ruscha, "Concerning 'Various Small Fires,' Edward Ruscha Discusses His Perplexing Publications," interview by John Coplans, *Artforum* 3 (February 1965): 25. Bochner implicitly acknowledged his interest in Ruscha's photography by including an image from Ruscha's book *Thirtyfour Parking Lots* (1967) in one of his magazine pieces. See Mel Bochner, "Alfaville, Godard's Apocalypse," *Arts Magazine* 42 (May 1968): 14–17.

21 For example, in Ruscha's book *Various Small Fires and Milk* (1964), we never see just the fire, but also its physical support, whether a pipe protruding from a man's mouth or a propane canister. Similarly, in *Babycakes* (1970) the details of the surface supporting the cake, its background, or even its wrapper encroach on the subject.

22 Ruscha also demonstrated no qualms about using photographs that he did not make. *Babycakes*, for example, credits four photographers other than

Ruscha, and the artist suggested that he would gladly use stock photography if the appropriate images were available: "It is not important who took the photos, it is a matter of convenience, purely." Ed Ruscha, "Concerning 'Various Small Fires,'" 25.

23 Mel Bochner in conversation with the author, 1999.

24 Lambert was a familiar presence among artists of Bochner's circle. Her photographs of Judd, Smithson, and LeWitt at work were published along with one of Bochner's grid drawings in John Perreault, "Union Made," *Arts Magazine* 41 (March 1967): 26–31.

25 Although the 1980s and 1990s have witnessed an erosion in the camera's claim on veracity, it is important to keep in mind that in the 1960s, before computer image editing, photography was still a highly credible "document." This concept of photography's "objectivity" is often invoked in art historical discussions of German *Neue Sachlichkeit* photography of the 1920s. Bochner would have had no specific knowledge of this "new objective" photography in the mid-sixties, though its impact would have trickled down to him through photographers such as Evans. On a more theoretical level, Roland Barthes' canonical 1961 characterization of photography as a "message without a code" would also have reinforced the medium's presumed "objectivity" in the mid-1960s. See Roland Barthes, "The Photographic Message" in *Image Music Text*, ed. and trans. Stephen Heath (New York: Hill and Wang, 1977). Finally, in terms of technology, Bochner remembers being struck by the fact that a lens is often referred to as an "objective," a label that codes the rhetoric of "objectivity" into photography's most basic apparatus. Mel Bochner in conversation with the author, 1999.

26 Robbe-Grillet's collection of short essays, *For a New Novel*, was published in English in 1965 and widely read by artists and critics at that time. In his criticism Robbe-Grillet proposes that the blunt description of objects or surfaces take the place of allusion, metaphor, and romantic notions of interiority. See Alain Robbe-Grillet, *For a New Novel*, trans. Richard Howard (New York: Grove, 1965).

27 Judd writes of John Chamberlain's crushed metal sculptures, "The crumpled tin tends to stay that way. It is neutral at first, not artistic, and later seems objective." Later in the same article Judd comments on new materials in sculpture, "Materials vary greatly and are simply materials. . . . There

is an objectivity to the obdurate identity of a material." See Judd, "Specific Objects," 183–87.

28 Mel Bochner in conversation with the author, 2000. Although "literalism" was an attribute Bochner pursued in his work, it is important to note the term was particularly charged in the mid-sixties, acting as a pivot between Minimalism and Modernist painting. In his highly influential (and contested) article "Art and Objecthood," Michael Fried attacked Minimalism's "literalist" bent, for so banishing illusionism as to make art almost indistinguishable from ordinary objects, and therefore non-art. See Michael Fried, "Art and Objecthood," *Artforum* 5 (June 1967): 12–23. Despite this negative assessment, the concept of literalism was actually very important to Fried's (as well as Greenberg's) understanding of Modernist painting's self-referentiality—but only to a point. For instance, in his 1966 review of Frank Stella's new paintings, Fried notes that the works acknowledge the "literal" shape of their support, but that the tension between "literal" shape and the "depicted" shape within the painting spares the works from being perceived themselves as literalist objects. In contrast, Fried writes of Judd and other Minimalists, "Their pieces cannot be said to acknowledge literalness; they simply are literal," a condition that Fried, as the young standard bearer for formalist criticism, found deplorable. Fried, "Shape as Form: Frank Stella's New Paintings," *Artforum* 5 (November 1966): 22.

29 Ironically, this strategy might be seen as the reverse of Fried's and Greenberg's attempt to spare Modernist painting from the non-art status total literalism would in their eyes imply. In their writing, they summoned "optical" illusionism to mitigate the literalism implied by Modernism's acknowledgment of the picture plane, while Bochner tried to harness illusionism to such an extent that it might lead to, rather than negate, literalism in photography. See also note 46.

30 The work is organized so that the two sets on the top half of the piece are both three-part progressions, while below hang one four-part series and another sequence of only two parts. When first exhibited in *Scale Models and Drawings*, the overhead photographs were originally at the bottom of each column, rather than below the diagram. Bochner later repositioned those overhead photographs directly beneath the drawn plans, creating a more explicit link between the diagram and the resulting structure.

31 Bochner, "The Serial Attitude," 28. In the 1870s, for the purpose of studying animal locomotion, Muybridge devised a battery of multiple cameras that took a series of pictures on separate negatives in rapid succession (fig. 13). In 1884, Eakins, who knew both Muybridge and his work, employed a slightly different method involving a single camera equipped with a rotating plate negative, so that all the images were made by a single apparatus (fig. 12). Working in France, Marey had developed a similar device in 1882, and shortly thereafter he arrived at his "chrono-photographe," capable of capturing up to 120 pictures per second on long strips of sensitized paper (fig. 11).

During the mid-sixties, information regarding this historic stop-action photography had become widely available and discussed in the art world, and Bochner's work was clearly understood in this context. See, for example, Dan Graham's article on Muybridge, which mentions the films of Godard and Warhol, as well as those of Bochner and Moskowitz; Dan Graham, "Muybridge Moments," *Arts Magazine* 41 (February 1967): 23–24. These historic stop-action photographs also gained major exposure in John Szarkowski's *Once Invisible*, a 1967 Museum of Modern Art exhibition of primarily "scientific" photography. The show, which Bochner visited, included a section devoted to "The Analysis and Synthesis of Time," with works by Muybridge and Marey, as well as satellite and laboratory photography. Bochner and his peers would have known Marey most prominently as the inspiration for Duchamp's *Nude Descending a Staircase* (1912), which Bochner illustrated in "The Serial Attitude" directly above a Marey image (fig. 11) he had culled from an article by Lucien Bull, "Marey's Cinematograph," *Visual Medicine* 2, no. 1 (March 1967): 32–37. In comparison with his paintings, Eakins's photographs of moving figures were less well known, but Bochner encountered examples of this work in a widely distributed study by Fairfield Porter, *Thomas Eakins* (New York: George Braziller, Inc., 1959).

32 LeWitt made two works of this sort, *Muybridge I* and *Muybridge II* (both of 1964), though his painting *Run I-IV* already acknowledged a less specific approach to the photographer as early as 1962. LeWitt asserted this priority in a much later work he made for *Artists and Photographs*, a 1970 box of multiples published by Marian Goodman (also containing a work of Bochner's; see note 91). LeWitt's contribution, *Schematic Drawing for Muybridge II*,

features the circular photographs of an approaching woman from *Muybridge II* and includes that work's 1964 date, almost as if LeWitt wished to claim his long-standing involvement with Muybridge, not to mention uninflected black-and-white photography.

33 Rosalind Krauss later observed a similar absurdity in Sol LeWitt's 1974 work *Variations of Incomplete Open Cubes*. See Krauss, "LeWitt in Progress" in *The Originality of the Avant-Garde and Other Modernist Myths* (Cambridge: MIT Press, 1985), 245–58.

34 Since Muybridge often rigged his cameras to take pictures of the same moving subject from different vantages at exactly the same time, many of his photographs demonstrate discontinuities similar to Bochner's. For example, in a work Bochner purchased in the sixties, Muybridge captures a bird in flight head on and in profile, but without the help of Muybridge's numbering it is often difficult to determine which pictures correspond to each other chronologically. Bochner was clearly very interested in this aspect of Muybridge's work, leading him to note, "Muybridge simultaneously photographed the same activity from 180°, 90°, and 45° and printed the three sets of photographs parallel horizontally. By setting up alternative reading logics within a visually discontinuous sequence he completely fragmented perception into what Stockhausen called, in another context, a 'directionless time-field'." Bochner, "The Serial Attitude," 28.

35 Some of Morris's early Minimalist work, such as the gray rectangular *Untitled (Cloud)* and *Untitled (Slab)* (both 1962), came closer than Judd's objects to achieving this effect of a unified gestalt, of which Morris wrote, "In the simpler regular polyhedrons such as cubes and pyramids one need not move around the object for the sense of the whole, the gestalt, to occur. One sees and immediately 'believes' that the pattern within one's mind corresponds to the existential fact of the object." Robert Morris, "Notes on Sculpture," *Artforum* 4 (February 1966): 44.

36 In her criticism, Krauss contradicted Judd's own anti-illusionistic rhetoric by pointing out the disjunction between a frontal view of a Judd object, in which boxes at first seem suspended from a horizontal beam, and a side view of the same object, which demonstrates that the boxes in fact support the bar. See Rosalind Krauss, "Allusion and Illusion in Donald Judd," *Artforum* 4 (May 1966): 24–26. Smithson, who like Bochner was involved with

exploring the perceptual tricks inherent in minimal sculpture, noted a similar effect in Judd's work: "It is impossible to tell what is hanging from what or what is supporting what. Ups are downs and downs are up." Robert Smithson, "Donald Judd" in *7 Sculptors*, exh. cat. (Philadelphia Institute of Contemporary Art, 1965), reprinted in *Robert Smithson: The Collected Writings*, ed. Jack Flam (Berkeley: University of California Press, 1996), 6.

37 Bochner would have encountered these perceptual problems not only through art, but also through reading Maurice Merleau-Ponty's writings on phenomenology. Bochner spent part of 1963 auditing philosophy courses at Northwestern University, then a leading center in the study of phenomenology. By the mid-sixties, Merleau-Ponty's writings were widely read by artists, including Smithson and Morris, and cited by a variety of critics including Krauss, Barbara Rose, and Nicholas Calas. Krauss, for example, refers to three different Merleau-Ponty texts in one article alone. One of the quotations she culls specifically targets the problem of multiple viewpoints raised in Judd's work and seized on by Bochner: "But in perception it [the object of perception] is 'real,' it is given as the infinite sum of an indefinite series of perspectival views in each of which the object is given but in none of which is it given exhaustively." Rosalind Krauss, "Allusion and Illusion in Donald Judd," 26, quoting Maurice Merleau-Ponty, "The Primacy of Perception" (1964).

A work such as Morris's *L-Beams* might be said to allow the viewer to discover the perceptual discrepancies experienced when viewing an object simultaneously from two or three vantages (since each of the three units is identical, but positioned differently). However, even this work makes such a recognition difficult, because the viewer may not at first realize that the units are in fact identical, given that they appear somewhat different. Krauss discusses this effect in Morris further in *Passages in Modern Sculpture* (Cambridge: MIT Press, 1981), 266–67.

38 Sasha M. Newman, "The Photo Pieces," 118.

39 One could argue that Bochner had all along intended specifically to critique the concept of literalism by adopting such an indirect and mediated medium as photography. Yet given his pains toward objectivity, as well as his own comments about his original interest in literalism, it seems more likely that this aspect of his critique was at first accidental, and only later developed more consciously.

40 The work was made for the exhibition *Monuments, Tombstones, and Trophies*, which ran from 16 March to 14 May 1967. At that time, the photographic panels were accompanied by a Photostat text panel, with typed quotations from *Webster's Dictionary*, Duchamp, Sartre, and John Daniels (plate 6). Although Bochner considered the panel part of the work, it has been omitted in later reproductions.

41 Bochner has remarked that the arrangement of the panels in this work was owed in part to an interest in Islamic tiling systems and the conflict between such two-dimensional patterns and the perspectival space within the photographs. The work has been discussed well by Joseph Jacobs in his exhibition catalogue *This Is Not A Photograph: Twenty Years of Large-Scale Photography 1966–1986* (Sarasota: The John and Mable Ringling Museum of Art, 1987).

42 In fact, several of the photographs depict the blocks in positions that would be impossible according to the laws of perspective, gravity, and human sight. Bochner forced this condition to an extreme in a later blueprint titled *Knot* (1968; plate 38). He made the work as part of an artist-in-residency program sponsored by E.A.T. [Experiments in Art and Technology] at Local One, Amalgamated Lithographers of America, in Manhattan. Aided by a skilled lithography technician, Bochner devised a mobius-like arrangement of blocks by manipulating the lithographic films to create a disjointed spiral completely ungoverned by a unified perspective. The work was never made into a final print, and only the blueprint "study" reproduced here survives. Bochner's manipulation of space and perspective in this work bears strong comparison with Al Held's paintings, begun in 1967, of geometric units in a discontinuous perspectival space.

43 To make this work, Bochner consecutively numbered the panels of *None Tangent*, and then rearranged them so that these numbers corresponded to the mathematical configuration of a "magic square." In "magic squares," the numerals in each row, column, and diagonal produce the same sum; although the arrangement of numerals may at first appear random, their placement is entirely predetermined. In "The Serial Attitude" Bochner reproduced Durer's 1514 engraving *Melencholia I*, which features an extremely legible "magic square." See Bochner, "The Serial Attitude," 28.

44 Bochner had all of his silhouette works industrially fabricated, so the cuts would correspond to the image as closely as possible. To arrive at the work's title, Bochner assigned each diagram of *36 Photographs* a letter, beginning in the upper left corner and moving to the right. The number corresponds to the image's vertical position in its column. *H-2* refers to the panel below the eighth drawing, while *H-3* is the photograph beneath it.

45 It is worth noting that, in the critical foment of the sixties, the relief was not deemed a universally viable artistic option. Morris, despite his earlier reliefs, eventually dismissed the format: "The relief has always been accepted as a viable mode. However, it cannot be accepted today as legitimate. The autonomous and literal nature of sculpture demands that it have its own, equally literal space—not a surface shared with painting." See Robert Morris, "Notes on Sculpture," *Artforum* 4 (Feb 1966): 43. Although Bochner was preoccupied with a similar literalism, he was equally drawn to the very interstitial quality of the relief that Morris condemned.

46 *Shape and Structure* (organized by Stella and Henry Geldzahler) appeared at the Tibor de Nagy Gallery, New York, in January 1965, while *The Shaped Canvas* was presented by Lawrence Alloway at the Guggenheim Museum from December 1964 to January 1965. Although Stella did not exhibit his own work in *Shape and Structure*, his objectlike canvases were an important precedent for the paintings in both these shows, just as his work had figured prominently in the early development of many Minimalist artists, such as Judd.

However, the extent to which Stella embraced this "objectness" was hotly debated, because a critic such as Michael Fried would have protested so literalist a reading of Stella's work. Fried did see Stella's arrangement of lines as acknowledging the literal shape of the canvas: "Stella is concerned with deriving or deducing pictorial structure from the literal character of the picture support." Yet Fried saw that literalism as always mitigated by some other factor (whether internal spatial illusion or the shimmering quality of reflective paint), which prevented the work from veering too far into the realm of "objecthood" that he disparaged in Minimalism. Stella himself seemed to be conflicted as to the extent of the literalism and "objectness" of his paintings. At one point he commented, "Any painting is an object and anyone who gets involved enough in this finally has to face up to the objectness of whatever it is that he's doing."

He later retreated a bit, however, by remarking, "When you stand directly in front of the painting it gives it just enough depth to hold it off the wall; you're conscious of this sort of shadow, just enough depth to emphasize the surface. In other words, it makes it more like a painting and less like an object, by stressing the surface." This tension would have been particularly interesting to Bochner, who reviewed Stella's 1966 exhibition at Leo Castelli Gallery and himself capitalized on the conflict between the illusionism of the pictorial surface and the shadow-casting, objectlike presence of his own reliefs. Michael Fried, *Three American Painters: Noland, Olitski, Stella*, exh. cat. (Cambridge: Fogg Art Museum, 1965), reprinted in *Art and Objecthood* (Chicago: University of Chicago Press, 1998), 251. Frank Stella, "Questions to Stella and Judd," interview by Bruce Glaser, ed. Lucy Lippard, *Art News* 65 (September 1966): 58–60. For further discussion of the critical debates surrounding the shaped canvas, see Meyer, "The Genealogy of Minimalism," 160–71.

47 Bochner's photograph might be seen to "reverse" the procedure behind the "deductive structure," because the shape of the object is derived from the contents of the image, as opposed to a canvas by Stella, for example, in which the marks on the surface are said to derive from the shape of the support. We might also think of *None Tangent* in similar terms; the grid structure of the photographic panels derives from the grid of sixteen blocks pictured in the image.

48 This effect is analogous to the perspectival phenomenon that we have already seen in several of Bochner's images since *12 Diagrams and 36 Photographs*.

49 Martin Kemp, *The Science of Art* (New Haven: Yale University Press, 1990), 49. Renaissance and Mannerist painters (who greatly interested both Bochner and Smithson) vigorously investigated this phenomenon through the development of "anamorphic" perspective, wherein a painted image is unrecognizable from straight on, but then pulls into focus when viewed from a particular angle or distance. The most well-known example of this practice may be Hans Holbein's *The Ambassadors* (1533), in which a blur at the bottom of the painting resolves into a skull when the viewer moves from a frontal to an oblique view of the painting.

50 Krauss, "Allusion and Illusion," 25. Ironically, Krauss's choice to read Judd's object against his own anti-illusionist rhetoric was not meant as an attack. Rather, she attempted to make his sculpture more palatable to formalist critics disapproving of his strong literalist bent—a strategy that inadvertently confirms the challenge perspectival illusionism posed to the literalist aims of Bochner's photography from *36 Photographs* through *H-2*.

51 For example, Krauss wrote of Judd's sculpture, "For now one sees the work in extension, that is, looking along its length one sees it in perspective. That one is tempted to read it as in perspective follows from the familiar repetitive rhythms of the verticals of the violet boxes which are reminiscent of the colonnades of classical architecture or of the occurrence at equal intervals of the vertical supporting members of any modular structure." Krauss, "Allusion and Illusion," 25.

52 Both of these sculptures consciously play with the difference between natural and artificial perspective. For example, *Plunge* (1966) (fig. 19) comprises ten structures of identical shape, which grow progressively taller (or smaller, depending on the viewer's position) as each structure's basic cubic unit varies incrementally between 14.5 and 19 inches. The viewer sees the work across a distance that would naturally cause some perspectival shrinkage, an effect either accentuated or mitigated by the fact that the units actually vary in size. Smithson further addressed perspective in a large number of works, including his *Enantiomorphic Chambers* (1965) and *Pointless Vanishing Point* (1967), as well as in writings such as his 1967 text "Pointless Vanishing Points," originally unpublished, now available in Smithson, *Robert Smithson: The Collected Writings*, 358–59. For further discussion of Smithson's involvement with perspective, see Ann Reynolds, "Robert Smithson: Learning From New Jersey and Elsewhere" (Ph.D. diss., City University of New York, 1993).

53 Michael Fried, "Ronald Davis: Surface and Illusion," *Artforum* 5 (April 1967): 37. Less than a year earlier, Fried had also discussed how the shapes within Stella's new paintings might be read as forms seen in perspective, yet unlike Davis's work, Stella's canvases themselves never appear as though in perspective. See Fried, "Shape as Form: Frank Stella's New Paintings," *Artforum* 3 (November 1966): 18–27. In a March 1967 *Art International* Article, Lucy Lippard also commented on a new interest in perspective among painters who sought simultaneously to explore perspectival illusion and affirm the flatness of the picture plane. See Lucy Lippard, "Perverse Perspectives," in *Changing: Essays in Art Criticism* (New York: E. P. Dutton & Co., Inc., 1971), 167–83.

54 In "The Serial Attitude," Bochner writes, "Perspective, almost universally dismissed as a concern in recent art, is a fascinating example of the application of prefabricated systems. In the work of artists like Ucello, Durer, Piero, Saendredam, Eakins (especially their drawings), it can be seen to exist entirely as methodology. It demonstrates not how things appear but rather the workings of its own strict postulates. As it is, these postulates are serial." Bochner, "The Serial Attitude," 31.

55 Mel Bochner in conversation with the author, 1999.

56 This image bears a striking resemblance to a photograph of a LeWitt sculpture in an advertisement for Dwan Gallery in *Art News* 65 (May 1966): 63 (fig. 18). The almost diagrammatic perspective of the ad's photograph reaffirms the high susceptibility of minimal sculpture to perspectival viewing, further confirming the link between perspective and Minimalism in Bochner's photography.

57 In his 1924–25 text on perspective, Erwin Panofsky describes a more dramatic occurrence of this effect as follows: "For while perspective projects straight lines as straight lines, our eye perceives them (from the center of projection) as convex curves. A normal checkerboard pattern appears at close range to swell out in the form of a shield." Erwin Panofsky, *Perspective as Symbolic Form*, trans. Christopher S. Wood (New York: Zone Books, 1991), 32–33.

58 Since linear perspective makes no allowances for this perceptual distortion, some artists and theorists have struggled to create an alternative perspectival system, often referred to as "curvilinear," which might more closely approximate the image formed by the human eye. For a brief discussion of the history of this topic, see Kemp, 241–49.

59 Panofsky, 31–32.

60 Although Panofsky correctly observes that under certain circumstances both the eye and camera apprehend straight lines as curves, he incorrectly identifies the spherical shape of the retina as the cause of that distortion: "Finally perspectival construction ignores the crucial circumstance that this retinal image—entirely apart from its subsequent psychological 'interpretation,' and even apart from the fact that the eyes move—is a projection not on a flat but on a concave surface." (Panofsky, 31).

This observation would not have been directly available to Bochner (Panofsky's writings were not yet translated into English), but he encountered a similar discussion about perspectival distortion (which also inaccurately blames perceptual distortion on the spherical retina) in Morris Kline's *Mathematics in Western Culture* (New York: Oxford University Press, 1953). Despite the inaccuracies of these explanations, a sketch in one of Bochner's notebooks dedicated to ideas for photographs shows the extent to which such theories may have informed his perspective photographs. On one page (plate 72) Bochner quickly penned a light bulb directed at a grid, the shadow of which curves around a sphere below. Above the sketch, he scrawled "project flat image on round surface," the very condition Panofsky describes in reference to the projection of images on the retina (or the camera's lens). For an assessment of the reliability of Panofsky's optics see Kim Veltman, "Panofsky's Perspective: A Half Century Later" in *La prospettiva rinascimentale: codificazioni e trasgressioni*, ed. Marisa Dalai Emiliani (Florence: Centro Di, 1980), 565–84.

61 Bochner himself mentioned this disparity in his article "The Serial Attitude." See note 54.

62 Within the context of the mid-sixties painting and sculpture exploring perspective, photography was uniquely suited to Bochner's investigation, because a two-dimensional painting was necessarily inadequate in testing perspective's physical relationship to the three-dimensional space it illustrates, while a sculpture could never sufficiently posit linear perspective in relation to the two-dimensional picture plane it serves. In his choice of photography, Bochner's approach to perspective was very close to that of Jan Dibbets, who began his *Perspective Correction* photographs the same year. In the earliest of these works, Dibbets would draw a distorted square on his studio wall or floor so that, when photographed, perspective would force the form into a perfect square. Though Dibbets's work was unknown to Bochner when he began his perspective photographs, Dibbets's understanding of photography is very similar to Bochner's since Dibbets's works only take shape and exist in photographic form (as opposed to the more "documentary" mode of conceptual photography). For example, the shape drawn on Dibbets's studio floor would no more constitute a "work" than Bochner's taped grid, and, as with Bochner, Dibbets's perspective

photographs capitalize on the camera's apprehension of a real, physical space posited against the two dimensions of the final print.

63 The fact that the edges of the inset panel fail to recede in line with the orthogonals of the one-point perspective background can be verified by extending the inset panel's edges to an imaginary vanishing point, which does not coincide with the vanishing point of the background photograph.

64 Bochner has identified his interest in topology and mapmaking (a passion shared by Smithson) as an additional inspiration for these crumpled photographs, which introduce a kind of topographic relief to his previously flat spatial expanses. Bochner's library includes several books on the subject, which he read in the mid-sixties.

65 Bochner actually conceived of this work, *Perspective Insert (Collapsed Center)*, before he considered exhibiting any of the crumpled perspectives on their own. Soon after, he dispensed with the background and made a version of the work showing just the "collapsed center," titled *Surface DeFormation*, followed by *Surface DeFormation (Crumple)*, a warped version of *Perspective One Point (Positive)*. Bochner also made his first "color" photographs at this time, by dyeing and spray-lacquering various black-and-white Photostat and photographic maquettes of the undulating perspectives (plate 21). Only later would he begin to use actual color film in photographs of viscous substances.

66 This process is clearly described in a study Bochner made for an artist's book, which he hoped would be editioned in 1969 by Marian Goodman's Multiples Gallery. The work, *Notes And Procedures: Photograph Series B/Part 2, 1966–1968*, was never published by Goodman but it survives in the form of a fourteen-page stapled booklet of ink drawings on graph paper (plate 71).

We should also note that although Bochner was almost alone in physically manipulating photographs within the context of the art world, other photographers were actively engaging a similar mode at the same time. Kenneth Josephson, Ray Metzker, and Jerry Uelsmann, among other mid-sixties figures, were experimenting with combining multiple negatives in a single print, rephotographing photographs, and, in Metzker's case, even exploring seriality. Though their work was known in New York (and was being shown and collected by the Department of Photography at the Museum of Modern Art), we should recognize that their

approach to deconstructing the photographic image did not develop in response to Minimalism or in relationship to the development of Conceptual art. Given their backgrounds as photographers, as well as the strong division between "art" and "photography" in the mid-sixties, they adopted methods similar to Bochner's in pursuit of largely different concerns.

67 Bochner said of his crumpled perspectives, "They were the first place where I thought of acting on the photograph as an object which bore no relationship to something which took place outside the photograph." Mel Bochner in conversation with the author, 1999.

68 As with "Minimalism," neither "Anti Form" nor "Post-Minimalism" denotes a unified movement, or even a specific set of artists or practices. Most generally, "Anti Form" implies a materially sensitive, process-based approach to abstract sculpture. ("Post-Minimalism," a broader term coined by Robert Pincus-Witten, includes that development as well as more specifically "conceptual" practices coming in the wake of Minimalism.) This looser, less geometric approach to sculpture first began to coalesce by 1966 in Lucy Lippard's landmark exhibition *Eccentric Abstraction* at the Fishbach Gallery. Yet the tendency did not gain true prominence until Robert Morris anthologized three artists from *Eccentric Abstraction* (Hesse, Bruce Nauman, and Keith Sonnier), along with Richard Serra and others, in his December 1968 group show *9 at Castelli*, in Leo Castelli's New York warehouse. In Morris's articles, "Anti Form" and "Notes on Sculpture, Part 4," which served as a de facto catalogue statement for the show, Morris argued for an art that eschewed preconceived objects. Instead, he advocated an artistic practice wherein the process of making a work is highly visible in the work's final form. The exhibition was widely reviewed and seen in stark opposition to Minimalism, as Max Kozloff opined in his *Artforum* cover story: "To recall the Primary Structures exhibition at the Jewish Museum two and a half years ago is to realize what a drastic change has occurred in the concept of spatial behavior, density, and abstraction as imagined by American sculpture." Robert Morris, "Anti Form," *Artforum* 6 (April 1968): 33–35, and "Notes on Sculpture, Part 4: Beyond Objects," *Artforum* 7 (April 1969): 50–54; Max Kozloff, "9 in a Warehouse," *Artforum* 7 (February 1969): 39–40.

Although Bochner could not be labeled an "Anti

Form" artist, it is necessary to consider his turn away from strict geometry in relation to the "drastic change" Kozloff identified in the years following *Primary Structures*. From the very beginning, Bochner had been interested in processes (as in seriality) more than in physical objects themselves, though obviously the labor of stacking and arranging blocks or releasing a shutter was hardly coded into his final photographs as much as the act of cutting and scattering might be visible in one of Le Va's or Morris's felt pieces.

69 Beginning in 1966, Hesse and Bochner spent much time together looking at and discussing each other's work. Although the critical literature on Hesse has persistently explored Bochner's impact on her art, far less attention has been paid to the reciprocal flow of ideas, clearly evidenced in Bochner's photographs of distorted perspectives and viscous substances. In addition to *Untitled or Not Yet*, Hesse made a number of works in which she warped a gridded net under the weight of its stuffing, such as *Vertiginous Detour* and an untitled group of three net bags stuffed with black weights (all made in 1966, before Bochner's "warps" and "crumples"). Hesse's simultaneous reliance and assault on the grid recurred in other works of this time, such as her drawings in which gridded circles are veiled in hazy applications of ink, and in her shallow reliefs of washers arranged in uneven grids and coated in Sculp-Metal. Here we might also note the importance of Smithson, a mutual friend of Hesse and Bochner, whose fascination with entropy would have contributed to Bochner's focus on more impermanent and variable materials.

70 Bochner recalls that this work seemed to come particularly "close" to his own thinking about photography (Mel Bochner in conversation with the author, 2000). Bochner would have encountered Nauman's photographs as early as September 1967, when *Artforum* published two of those pieces, others of which were exhibited in Nauman's solo show at the Castelli Gallery the following January. Nauman, along with Smithson, shared Bochner's interest in early satellite photography and images of the moon, which had become widely publicized in the mid-sixties. Nauman's *Composite Photo of Two Messes on the Studio Floor* (1967) specifically alludes to such photography and might be compared on those grounds with the small-scale "topographic" effect of *Surface Dis/Tension*. The connection between lunar photography and

Nauman's images is discussed in Neil Benezra and Kathy Halbreich, *Bruce Nauman: Exhibition Catalogue and Catalogue Raisonné*, ed. Joan Simon (Minneapolis: Walker Art Center; New York: Distributed Art Publishers, 1994), 210.

71 Bochner remembers at this point feeling more freedom in part because he saw no market for his photography in New York art galleries. Once the pressure of making a body of work for exhibition and sale eased, he put less stress on concerns such as the quality of the final print and visual consistency between his photographs. Bochner's experience with the Polaroid led him to other experiments with negativeless photography, including his *Smears* (1968; plates 33–37). For these works, he began by placing a number of household substances on glass scientific slides from which he hoped directly to make positive prints. At the time, that goal proved technologically infeasible, because he would have had to first make an intermediary negative, a choice he rejected as contrary to the spirit of a project so vested in the literalist aim of making photography a more direct process. Instead, he chose to project the slides on the wall, but the later proliferation of silver dye bleach print (Cibachrome) technology has allowed him to make positive prints directly from the slides.

72 E.A.T. was founded in 1966 by Rauschenberg and the physicist Billy Klüver. The organization was designed not only to make technology more financially accessible to artists, but also to provide artists and engineers the possibility of collaborating on their work. Bochner participated in three separate E.A.T. projects: one placed him at Manhattan's Amalgamated Lithographers of America (see note 42); the second allowed him to hire a professional product photographer; and the third placed him in a residency at the Singer Lab, a topic to which I will return.

73 An even more general comparison of these photographs with painting seems apt, given Bochner's play with texture and facture. Clearly, the Vaseline "brush strokes" might be compared to those of Robert Ryman, just as the skeins of shaving cream allude to Jackson Pollock. Of course, in the final photographs these textured surfaces are reduced to a smooth finish, just as the painterly gesture is made trivial by the household materials.

74 Bochner has attributed some of his interest in these slick, visceral materials to his reading of Sartre's *Being and Nothingness*, the final section of which discusses the physical sensation of the "slimy" (*visqueux*) (Mel Bochner in conversation

with the author, 1999). In light of this, it is impossible to ignore the bodily associations of materials like mineral oil, shaving cream and Vaseline, which are applied not only to the body, but also seem somehow *of* the body. With allusions to viscera and sexual fluids, not to mention the bloody ooze of the iodine, the photographs quite easily raise some of the same corporeal references as work by Hesse and Nauman, for example. Yve-Alain Bois and Rosalind Krauss acknowledged these connotations by including images from *Transparent and Opaque* in their 1996 exhibition, *L'Informe: Mode d'emploi* at the Centre Pompidou, Paris. See Yve-Alain Bois and Rosalind Krauss, *Formless: A User's Guide* (New York: Zone Books, 1997).

Despite these associations, in Bochner's photography the texture and materiality of the referent is always concealed behind the slick gloss of the photographic print, making the image seem ultimately less "bodily" than the more sculptural work of his contemporaries, such as Nauman and Hesse. This point is not meant to devalue Bochner's photographs, but only to question the extent to which issues of sex, and even "Anti Form," were his primary concern. Although these associations are readily available, they ultimately seem secondary, especially given that the title *Transparent and Opaque* directs our attention toward other associations, namely the power and effect of light.

75 Bochner had the photographer shoot color slides, from which it was necessary to make intermediary negatives before the final C-prints. At the time, he remembers being unhappy with the quality of the color, because the slides' intensity was dulled in the process of first making internegatives and then prints. In the 1990s, Bochner has since been able to make positive prints from slides using silver dye bleach technology, a technique that maintains the vibrancy of the original color slides.

76 Bochner made these two photographs during his residency at the Singer Lab, discussed below.

77 As with perspective, color theory has spawned a broad literature throughout art history and is equally concerned with the problem of reconciling human perceptual experience with a set of rigorously defined scientific axioms. Given this tension between color's visual and verbal formulations, as well as its centrality in artistic experience, it should not be surprising that Bochner would choose to isolate this phenomenon as the "subject" of his work.

78 Panofsky elaborates this metaphor, as follows: "The

surface is now no longer the wall or the panel bearing the forms of the individual things and figures, but rather is once again the *transparent plane* through which we are meant to believe that we are looking into a space, even if that space is still bounded on all sides" (emphasis added). Panofsky, 55.

79 Duchamp's example also provides a useful step in Bochner's thinking, because he was no doubt struck by the elder's literal punning on the picture window as a plane of glass in works such as *The Bride Stripped Bare By Her Bachelors Even* (1915–23) and *To Be Looked at (From the Other Side of the Glass) With One Eye, Close to, For Almost an Hour* (1918).

80 "Singer Company Announces Artist-In-Residence," press release, 17 September 1968, E.A.T. Klüver Document #89, Museum of Modern Art Library, New York.

81 This quotation comes from Bochner's undated application to E.A.T., E.A.T. Box 6, F 39, The Getty Research Institute, Research Library Special Collections and Visual Resources, Los Angeles.

82 Bochner made two numbered photocopies of *The Singer Notes*, which he spiral bound in plastic.

83 Here, the blur of the racing blocks more closely approximates the model of motion photography established by Eakins and Marey than do the discrete units of *36 Photographs*, which owed more to Muybridge.

84 Mel Bochner in conversation with the author, 2000. Bochner may have returned to the concept of measurement by way of these discussions with the scientists, but he would also have been extremely aware of artworks that self-consciously referenced the concept of measurement, such as Duchamp's *Three Standard Stoppages* (1913–14), Johns's numerous paintings including rulers, and Morris's ruler sculptures and reliefs (1963–64).

85 Only one of these five pictures—the one measuring between a wall molding and a piece of black cloth—actually charts a precise distance between two physical points. Even the "10"" measurement from the spray can to the molding seems unmotivated, because it does not terminate at the can's edge or centered nozzle, but somewhere in-between. Of course, Bochner may actually have measured precisely to the canister's center but in attempting to avoid a frontal view in which the nozzle would block the mark on the wall, he chose a camera angle in which perspectival parallax makes the mark appear misaligned.

Had Bochner sought to measure distances accurately between objects in the lab, it seems unlikely that he would have always used "round" measurements with no fractions, such as a foot, a yard, or "10"" (as opposed to 7 3/4"). By the same token, had he sought to make the measurements span two "landmarks," he might easily have designated a camera angle or moved the spray can so that its nozzle was perfectly in line with the measurement.

86 Mel Bochner in conversation with the author, 2000.

87 Bochner did, on occasion, make individual photographs after 1969, but these number fewer than five, and he never focused consistently on the medium again, except in the case of reprinting old images or negatives.

88 Bochner has commented on the specific link he saw between his *Measurement* installations and the medium of photography. For him, the distances indicated on the wall were in some ways a projection of the room's "negative" (i.e., blueprint) directly onto the space (Mel Bochner in conversation with the author, 2000). One page from *The Singer Notes* shows quick studies for rooms marked with measurements, as well as a room in which sits a projector of some sort (plate 75). For a detailed discussion of Bochner's *Measurement* installations see Field, "Mel Bochner: Thought Made Visible," 34–40, and Yve-Alain Bois, "The Measurement Pieces: From Index to Implex" in Field, *Mel Bochner: Thought Made Visible, 1966–1973*, 167–75.

89 For Bochner, the term "pictorial" was equated with "representational" in this context. His use of the word should not be confused with "pictorialist" photography.

90 Rosalind Krauss, "Sense and Sensibility," *Artforum* 12 (November 1973): 48.

91 Although I have mentioned the art world's hostility toward photography at the moment Bochner took up the medium, the very fact of Goodman's publication reveals the extent to which photography had become accepted in such a short time. The box also included contributions by Ruscha, Rauschenberg, Christo, Tom Gormley, Douglas Huebler, Alan Kaprow, Michael Kirby, Richard Long, Robert Morris, Dennis Oppenheim, Bernar Venet, and a text by Lawrence Alloway.

92 Bochner intentionally falsified three of the quotations to cast doubt on their veracity, just as the work as a whole questions the truth value of photography. The quotations were culled from a large group that Bochner had assembled for an unpublished article titled "Dead Ends and Vicious Circles" (1969).

Technical Note

All works in plates section are courtesy of the artist and Sonnabend Gallery, unless otherwise noted. Dimensions are given in inches and centimeters; height precedes width. When two dates are given for a work, the first indicates the date the negative or slide was made, and the second indicates the date of the print reproduced in the catalogue. In some cases, Bochner used a different photographic process in making the later prints. For example, silver dye bleach print (Ilfochrome) technology, formerly known as Cibachrome, was not readily available in the mid-sixties, but Bochner used the process for all his later color prints. Changes in printing process and size are as follows:

Surface Deformation/Crumple (plate 22) was originally a gelatin silver print mounted on Masonite, while the later print, identical in format and process, is mounted on aluminum.

The maquette for *Crumple* (plate 24) was originally a silhouetted, Tintex-dyed Photostat from which Bochner made a slide in 1967. He later made a silver dye bleach print (Ilfochrome) of the slide and silhouetted it like the earlier Photostat.

Transparent and Opaque (plate 32) was printed in 1968 as a group of 8 x 10 in. (20.3 x 25.4 cm) C-iprints. At that time Bochner was unsatisfied with the prints, which he felt did not satisfactorily capture the color saturation and texture of the photographed substances. The original slides were later reprinted at a larger size as silver dye bleach prints (Ilfochrome).

The *Smears* (plates 33–37) were not printed when Bochner conceived them in 1968. At that time, Bochner put household substances in glass scientific slides, from which he hoped to make positive prints. That approach proved technically infeasible without first making a negative of the slide, a step that would have compromised Bochner's interest in making a positive photographic print directly from a substance itself. Instead of making prints, Bochner chose to project the slides on a wall, though the later availability of Cibachrome (now Ilfochrome) silver bleach printing technology has allowed Bochner to make positive prints from the original glass slides.

Roll (plate 41) was first printed as a series of 8 x 10 in. (20.3 x 25.4 cm) gelatin silver prints and later reprinted at a larger size.

Photography Cannot Record Abstract Ideas (plate 50) was first printed as an 8 x 10 in. (20.3 x 25.4 cm) C-print, and later reprinted as a silver dye bleach print (Ilfochrome) at a larger size.

Photographs

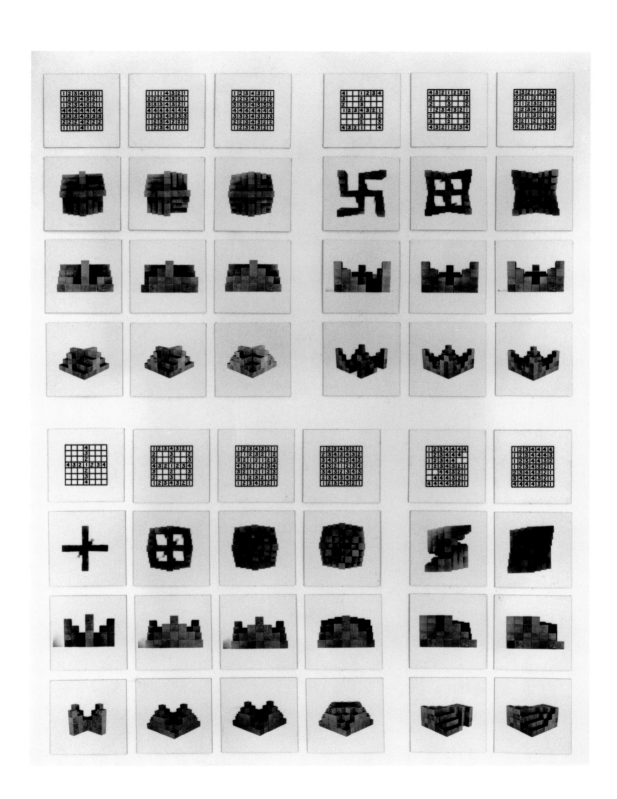

1

36 Photographs and 12 Diagrams, 1966
36 gelatin silver prints and 12 pen-and-ink drawings
mounted on board
8 x 8 in. (20.3 x 20.3 cm) each panel; 73 x 55 in.
(185.4 x 139.7 cm) overall
Collection Städtische Galerie im Lenbachhaus, Munich

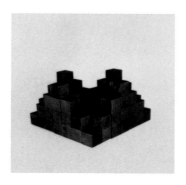

2

3 Photographs and 1 Diagram (Row H), 1966–67
4 gelatin silver prints mounted on board
20 x 20 in. (50.8 x 50.8 cm) each panel; 90 x 20 in.
(228.6 x 50.8 cm) overall

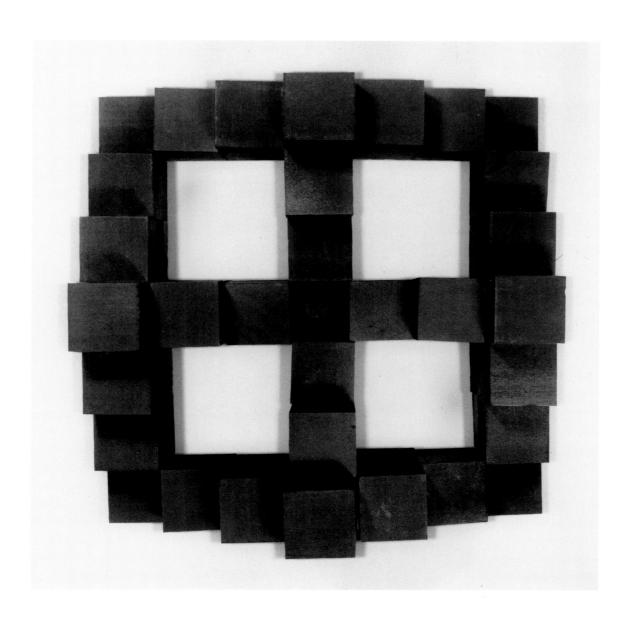

3

H-2, 1966–67
Silhouetted gelatin silver print mounted on Masonite
45 ¹⁄₄ x 45 ¹⁄₄ in. (114.9 x 114.9 cm)

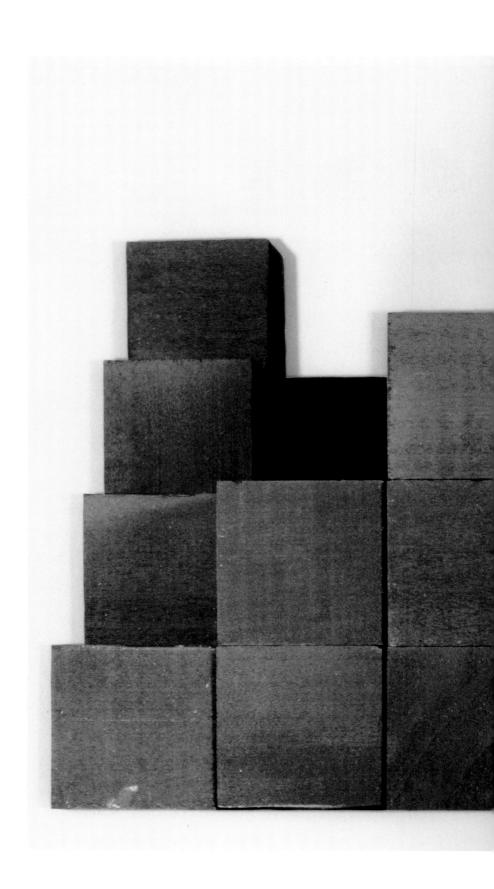

4
H-3, 1966–67
Silhouetted gelatin silver print mounted on Masonite
46 ¼ x 79 ½ in. (117.5 x 201.9 cm)

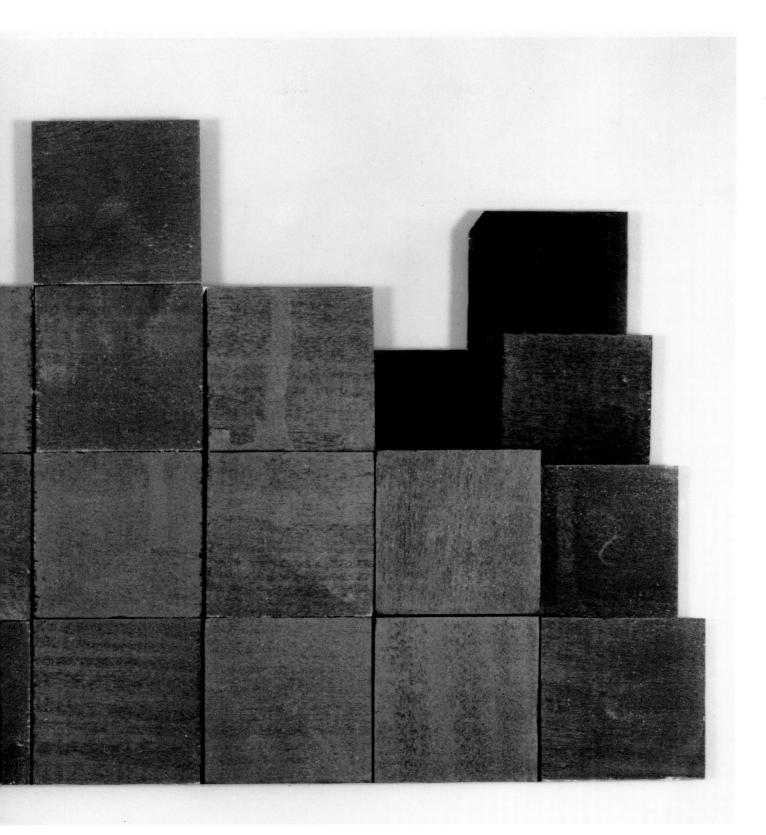

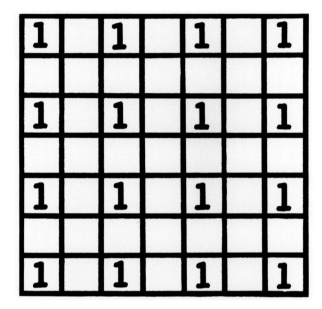

5
Photograph-Blocks (Four by Four), 1967
4 gelatin silver prints mounted on board
12 ¹/₄ x 12 ¹/₄ in. (31.1 x 31.1 cm) each panel

Four Comments Concerning-

"PHOTOGRAPH - BLOCKS: PROJECT FOR A MONUMENT EXHIBITION"

1. "Block (blok), n. - 1. A bulky, solid piece of wood, stone or the like, usually with one or more flat faces... 6. A quantity, number, or section of things dealt with as a unit."
 Webster's Dictionary

2. "I would like to see photography make people despise painting, until something else will make photography unbearable."
 Marcel Duchamp

3. "Things are entirely what they appear to be."
 Jean-Paul Sartre

4. "It is difficult to understand why any artist would want to make a monument in the first place."
 John Daniels

 Mel Bochner

Four Comments Concerning: Photograph-Blocks, 1967
Photostat mounted on board
12 1/4 x 12 1/4 in. (31.1 x 31.1 cm)

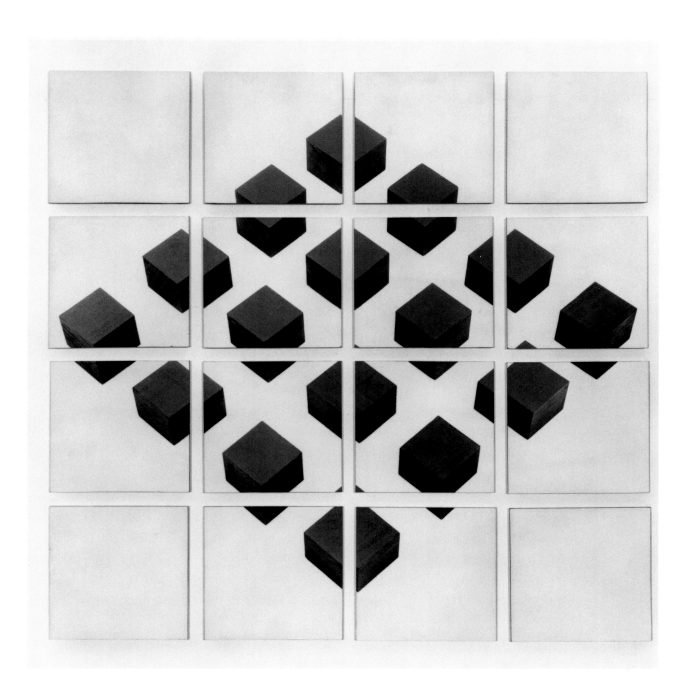

7

None Tangent, 1967
Gelatin silver print cut into 16 parts and mounted
on Masonite
10 x 10 in. (25.4 x 25.4 cm) each panel, 44 x 44 in.
(111.8 x 111.8 cm) overall

8

Sixteen Isomorphs (Negative), 1967
16 gelatin silver prints mounted on board
19 ¹/₂ x 19 ¹/₂ in. (49.5 x 49.5 cm) each panel,
89 x 140 in. (226.1 x 355.6 cm) overall

9

Constants and Variables: Striations (Curved), 1967
Gelatin silver print mounted on Masonite
53 $^1/_2$ x 60 in. (135.9 x 152.4 cm)

10

Isomorphic Circles (Compass #1): Negative, 1967
Gelatin silver print mounted on Masonite
29 1/2 in. (39.4 cm) diameter

11

Magic Squares (Visually Random #1) A & B, 1967
2 gelatin silver prints
19 ¼ x 19 ¼ in. (48.9 x 48.9 cm) each

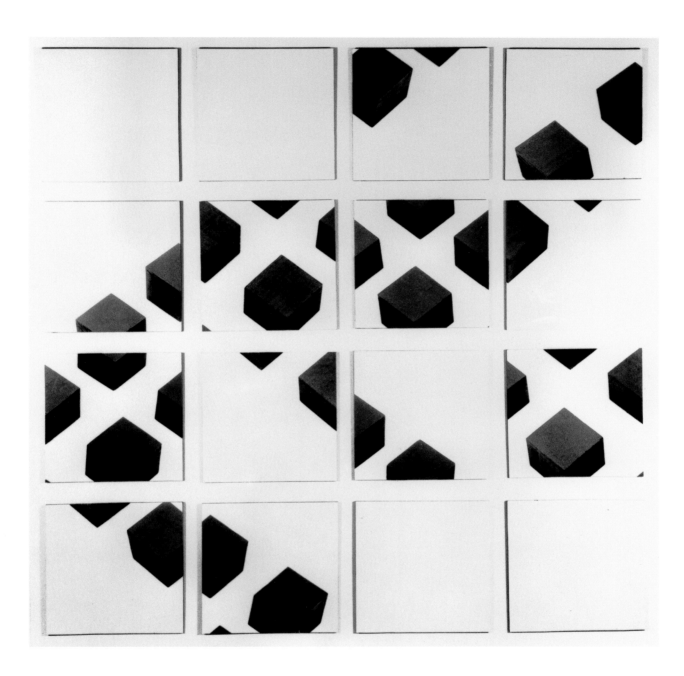

12

Perspective: One Point (Positive), 1967
Gelatin silver print mounted on Masonite
49 x 47 ¹/₂ in. (124.5 x 120.7 cm)
Collection Städtische Galerie im Lenbachhaus, Munich

13

Perspective: Two Point (Negative), 1967
Gelatin silver print mounted on Masonite
48 x 70 1/2 in. (121.9 x 179.1 cm)

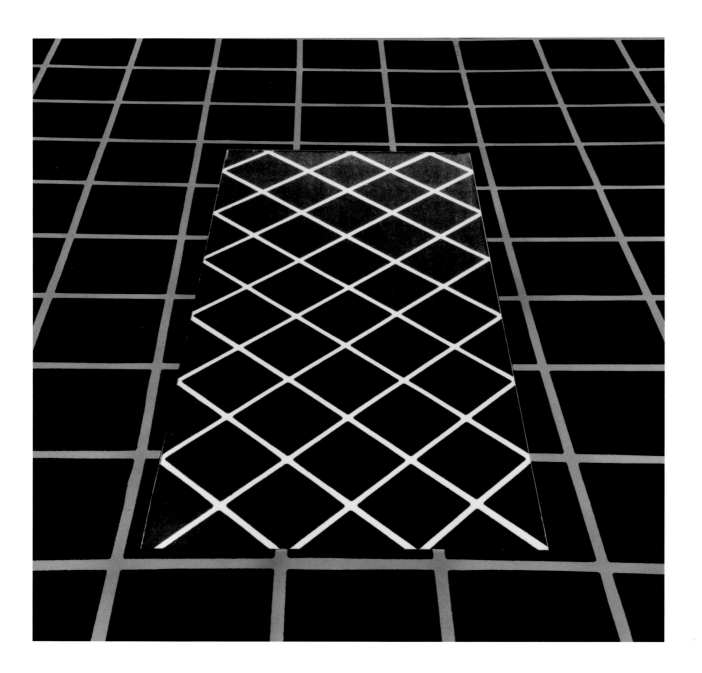

14

Perspective Insert (Two in One), 1967
Gelatin silver print mounted on Masonite
48 x 48 in. (121.9 x 121.9 cm)

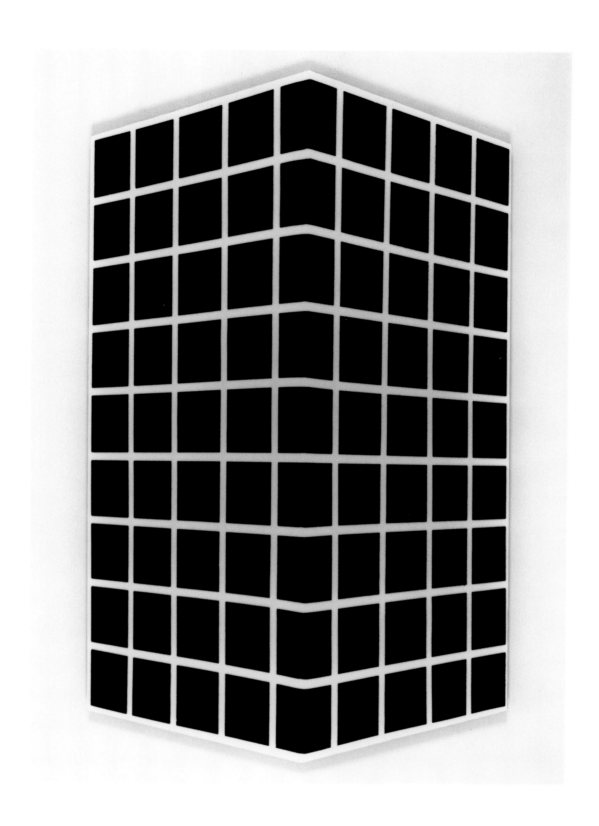

15
Convex Perspective, 1967
Silhouetted gelatin silver print mounted on Masonite
45 1/2 x 27 1/4 in. (115.6 x 69.2 cm)
Collection David Nolan and Carol Eckman, New York

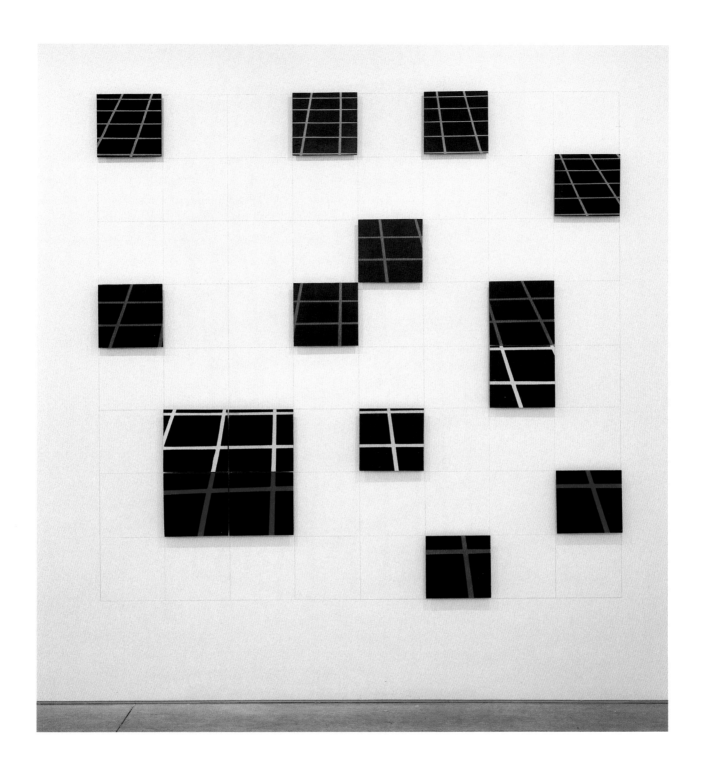

16

Dispersed Perspective (One Point): R. W. B., 1967
Spray lacquer on gelatin silver print cut into 16 parts
and mounted on Masonite, and graphite on wall
10 x 10 in. (25.4 x 25.4 cm) each panel, 80 x 80 in.
(203.2 x 203.2 cm) overall

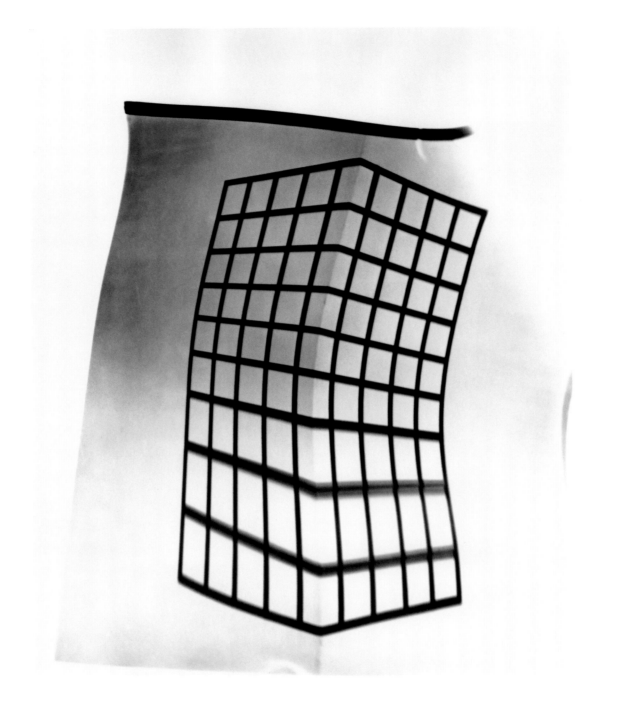

17

Warp (#1), 1967
Gelatin silver print
10 x 8 in. (25.4 x 20.3 cm)

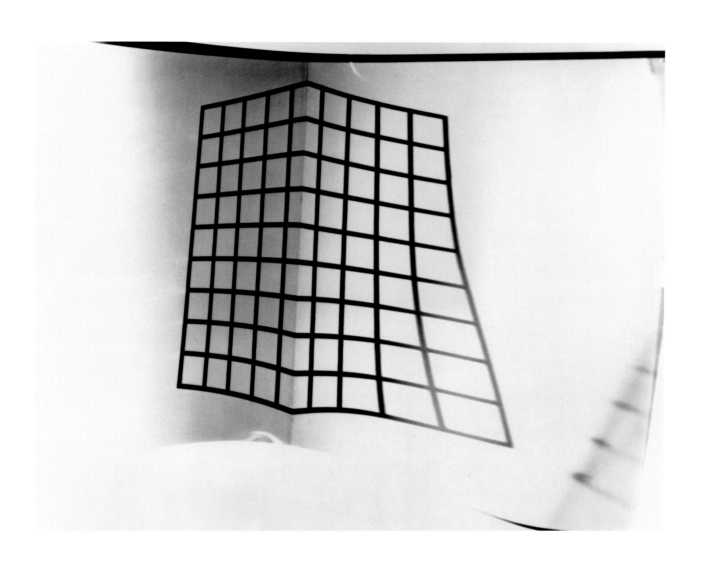

18

Warp (#2), 1967
Gelatin silver print
8 x 10 in. (20.3 x 25.4 cm)

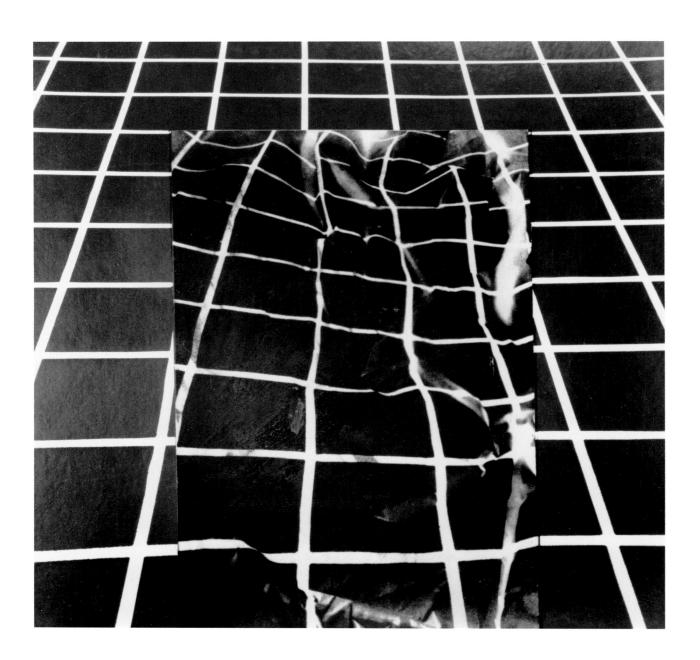

19

Perspective Insert (Collapsed Center), 1967
Gelatin silver print mounted on board
48 x 48 1/2 in. (121.9 x 123.2 cm)

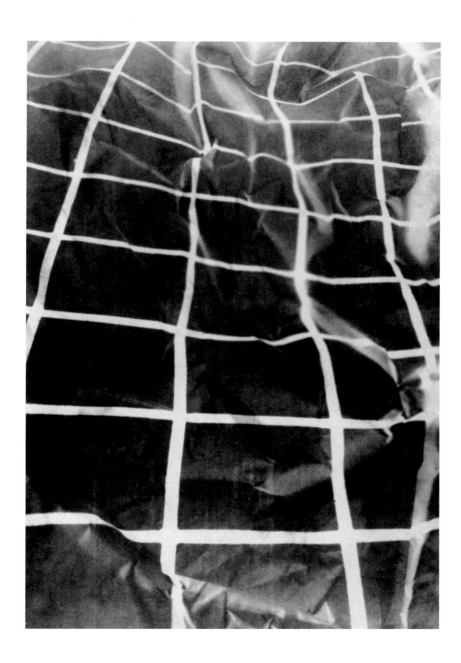

20
Surface Deformation, 1967
Gelatin silver print mounted on Masonite
30 x 20 in. (76.2 x 50.8 cm)

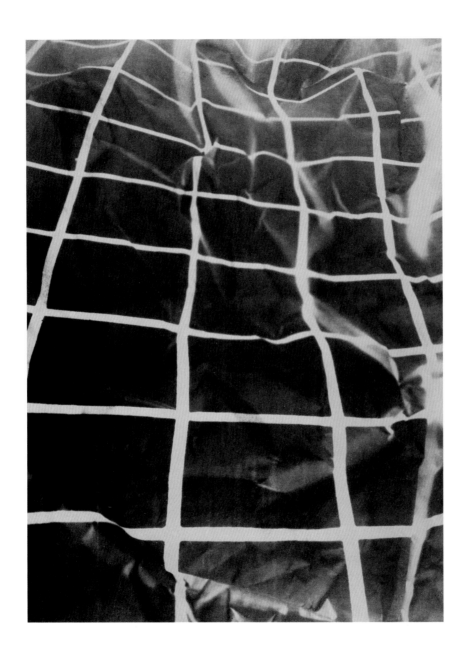

21

Surface Deformation (Green), 1967
Fabric dye on Photostat
11 x 7 ⁵/₈ in. (27.9 x 19.4 cm)

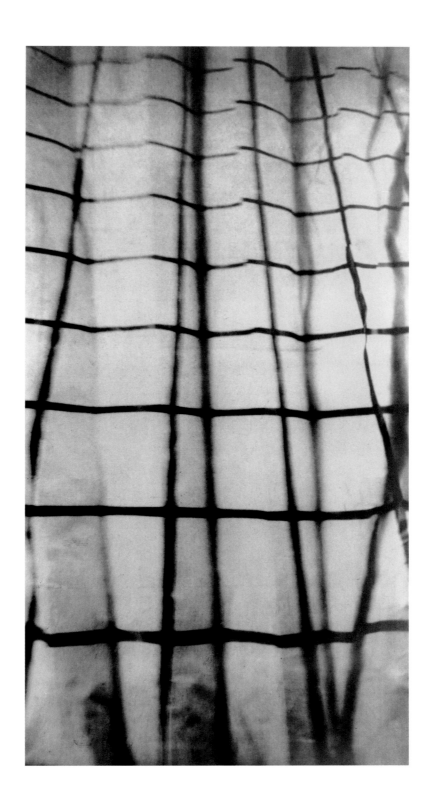

22

Surface Deformation/Crumple, 1967/2000
Gelatin silver print mounted on aluminum
52 x 28 in. (132.1 x 71.1 cm)
Collection Suzanne Cohen, Baltimore

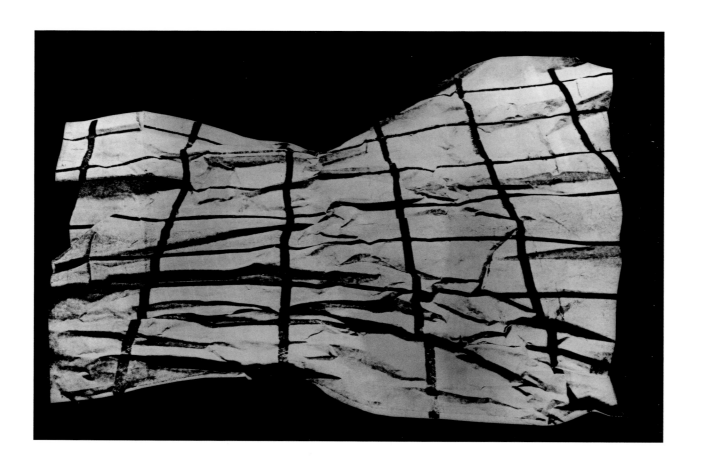

Crumple (Horizontal), 1967
Gelatin silver print
8 x 10 in. (20.3 x 25.4 cm)

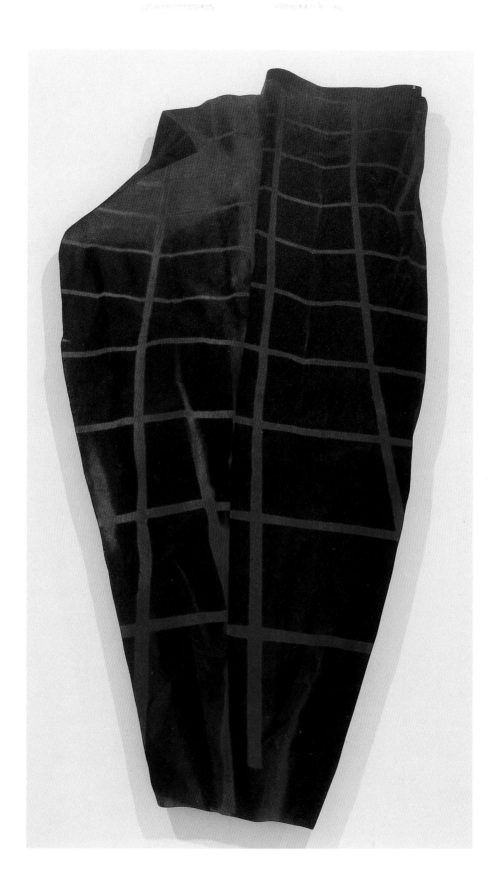

24

Crumple, 1967/1994
Silhouetted silver dye bleach print (Ilfochrome)
mounted on board
31 1/2 x 15 in. (80 x 38.1 cm)

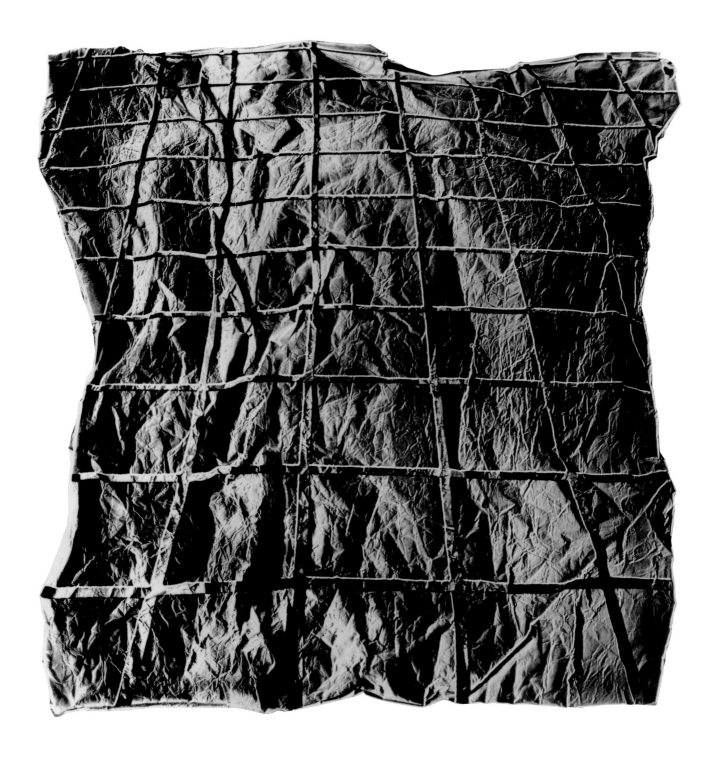

25

Surface Dis/Tension, 1968
Silhouetted composite gelatin silver print
mounted on board
72 x 68 in. (182.9 x 172.7 cm)

26

Viscosity (Mineral Oil), 1968
Color Polaroid
4 1/4 x 3 3/8 in. (10.4 x 8.6 cm)

27

Grid (Shaving Cream), 1968
Color Polaroid
4 ¹/₄ x 3 ³/₈ in. (10.4 x 8.6 cm)

28

Transparent Plane #1, 1968
2 color Polaroids
3 3/8 x 4 1/4 in. (8.6 x 10.4 cm) each

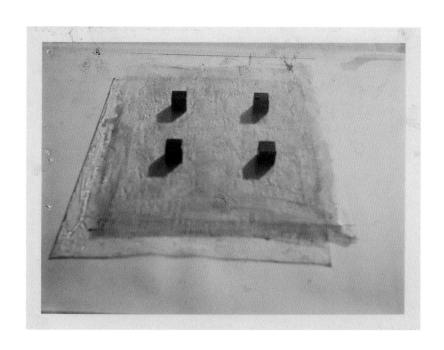

29

Transparent Plane #2, 1968
2 color Polaroids
3 3/8 x 4 1/4 in. (8.6 x 10.4 cm) each

30

Transparent Plane #3, 1968
Color Polaroid
4 1/4 x 3 3/8 in. (10.4 x 8.6 cm)

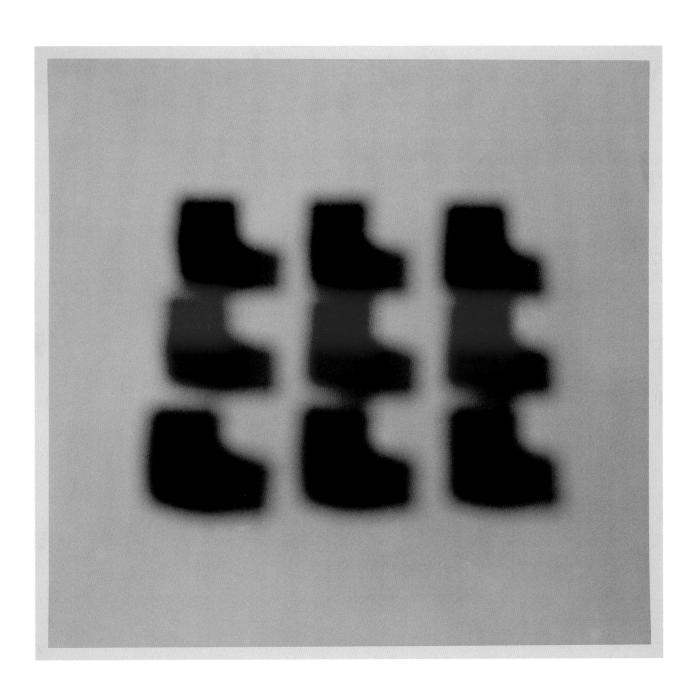

31
Out-of-Focus, 1968
C-print
8 x 8 in. (20.3 x 20.3 cm)
Collection Christophe Cherix, Geneva

32

Transparent and Opaque, 1968/1998
12 Silver dye bleach prints (Ilfochrome)
16 x 20 in. (40.6 x 50.8 cm) each
Collection Whitney Museum of American Art, New York

Transparent and Opaque, 1968/1998

32

Transparent and Opaque, 1968/1998

Transparent and Opaque, 1968/1998

33

Smear #1, 1968/1998
Silver dye bleach print (Ilfochrome)
from a handmade slide
16 x 16 in. (40.6 x 40.6 cm)

34

Smear #2, 1968/1998
Silver dye bleach print (Ilfochrome)
from a handmade slide
16 x 16 in. (40.6 x 40.6 cm)

35

Smear #3, 1968/1998
Silver dye bleach print (Ilfochrome)
from a handmade slide
16 x 16 in. (40.6 x 40.6 cm)

36

Smear #4, 1968/1998
Silver dye bleach print (Ilfochrome)
from a handmade slide
16 x 16 in. (40.6 x 40.6 cm)

37

Smear #5, 1968/1998
Silver dye bleach print (Ilfochrome)
from a handmade slide
16 x 16 in. (40.6 x 40.6 cm)

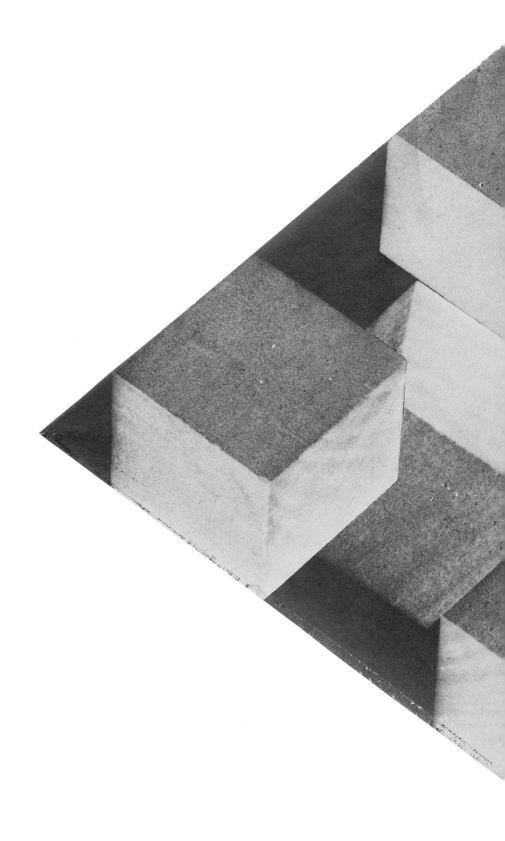

38
Knot, 1968
Cyanotype
15 x 20 in. (38.1 x 50.8 cm)

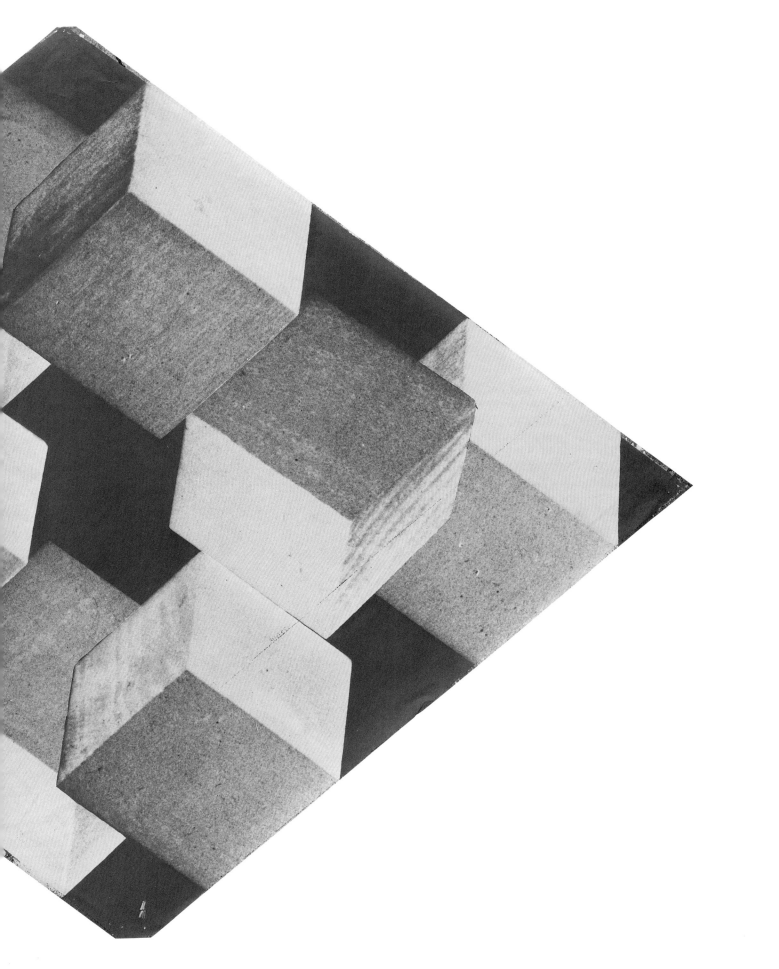

39

Polarized Light (Red/Yellow), 1968
C-print
10 x 8 in. (25.4 x 20.3 cm)

40

Polarized Light (Purple/Green), 1968
C-print
10 x 8 in. (25.4 x 20.3 cm)

41
Roll, 1968/1998
8 gelatin silver prints
20 x 24 in. (50.8 x 61 cm) each
Collection Whitney Museum of American Art, New York

41
Roll, 1968/1998

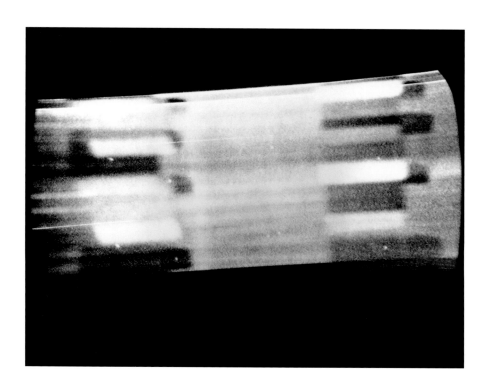

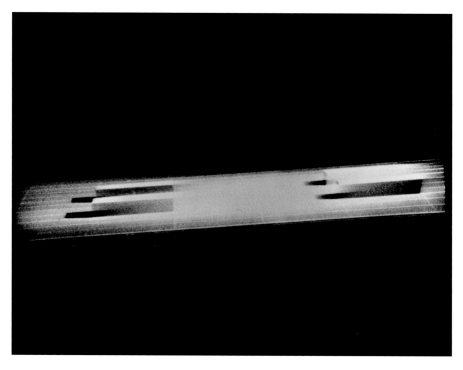

Singer Lab Measurement (#1), 1968
Gelatin silver print
10 x 8 in. (25.4 x 20.3 cm)

43
Singer Lab Measurement (#2), 1968
Gelatin silver print
10 x 8 in. (25.4 x 20.3 cm)

Singer Lab Measurement (#3), 1968
Gelatin silver print
10 x 8 in. (25.4 x 20.3 cm)

45

Singer Lab Measurement (#4), 1968
Gelatin silver print
10 x 8 in. (25.4 x 20.3 cm)

46

Singer Lab Measurement (#5), 1968
Gelatin silver print
10 x 8 in. (25.4 x 20.3 cm)

47

Actual Size (Face), 1968
Gelatin silver print
22 x 14 ¹/₄ in. (55.9 x 36.2 cm)

48

Actual Size (Hand), 1968
Gelatin silver print
22 x 14 ¼ in. (55.9 x 36.2 cm)

Misunderstandings (A Theory of Photography), 1967–70
10 photo-offset prints on note cards, enclosed in a manila envelope
5 x 8 in. (12.7 x 20.3 cm) each

I WOULD LIKE TO SEE PHOTOGRAPHY MAKE PEOPLE
DESPISE PAINTING UNTIL SOMETHING ELSE WILL
MAKE PHOTOGRAPHY UNBEARABLE.

MARCEL DUCHAMP

I WANT TO REPRODUCE THE OBJECTS AS THEY
ARE OR AS THEY WOULD BE EVEN IF I DID
NOT EXIST.

TAINE

PHOTOGRAPHY CANNOT RECORD ABSTRACT IDEAS.

ENCYCLOPEDIA BRITANNICA

LET US REMEMBER TOO, THAT WE DON'T HAVE TO TRANSLATE SUCH PICTURES INTO REALISTIC ONES IN ORDER TO 'UNDERSTAND' THEM, ANY MORE THAN WE NEED TRANSLATE PHOTOGRAPHS INTO COLORED PICTURES, ALTHOUGH BLACK-AND-WHITE MEN OR PLANTS IN REALITY WOULD STRIKE US AS UNSPEAKABLY STRANGE AND FRIGHTFUL. SUPPOSE WE WERE TO SAY AT THIS POINT: 'SOMETHING IS A PICTURE ONLY IN A PICTURE-LANGUAGE!

LUDWIG WITTGENSTEIN

Misunderstandings (A Theory of Photography), 1967–70

THE TRUE FUNCTION OF REVOLUTIONARY ART IS
THE CRYSTALLIZATION OF PHENOMENA INTO
ORGANIZED FORMS.

MAO TSE-TUNG

IN MY OPINION, YOU CANNOT SAY YOU HAVE
THOROUGHLY SEEN ANYTHING UNTIL YOU HAVE A
PHOTOGRAPH OF IT.

EMILE ZOLA

PHOTOGRAPHY IS THE PRODUCT OF COMPLETE ALIENATION.

MARCEL PROUST

THE PHOTOGRAPH KEEPS OPEN THE INSTANTS WHICH
THE ONRUSH OF TIME CLOSES UP; IT DESTROYS
THE OVERTAKING, THE OVERLAPPING OF TIME.

MAURICE MERLEAU-PONTY

Misunderstandings (A Theory of Photography), 1967–70

PHOTOGRAPHS PROVIDE FOR A KIND OF PERCEPTION
THAT IS MEDIATED INSTEAD OF DIRECT...
WHAT MIGHT BE CALLED 'PERCEPTION AT
SECOND HAND.'

JAMES J. GIBSON

50

Photography Cannot Record Abstract Ideas, 1969/1998
Silver dye bleach print (Ilfochrome)
16 x 20 in. (40.6 x 50.8 cm)

CANNOT RECORD ABSTRACT IDEAS.

ENCYCLOPEDIA BRITANNICA

Drawings

PROJECTED PLAN FOR
42 COLOR PHOTOGRAPHS
TRI-AXIAL ROTATION
OF A CUBE
MEL BOCHNER 1966

51

Projected Plan For 42 Color Photographs
(Tri-Axial Rotation of a Cube), 1966
Pen and ink and colored pencil on graph paper
17 3/8 x 22 1/8 in. (44.1 x 56.2 cm)

THREE SHOTS OF EACH PIECE

A. DIRECTLY ABOVE & IN THE CENTER OF
B. DIRECTLY IN FRONT AT GROUND LEVEL
C. AT 45°∠ LOOKING DOWN 45°

TOP VIEW:

A.

B.

C.

FRONT VIEW:

A.

B.

C.

SIDE VIEW:

A.

B.

C.

Three Shots of Each Piece
(Study for 36 Photographs and 12 Diagrams), 1966
Pen and ink on graph paper
11 x 8 ¼ in. (27.9 x 21.6 cm)

A

16	2	3	13
5	11	10	8
9	7	6	12
4	14	15	1

B

16	1	12	5
2	11	6	15
7	14	3	10
9	8	13	4

C

16	1	13	4
7	10	6	11
2	15	3	14
9	8	12	5

D

12	4	13	5
1	9	16	8
15	7	2	10
6	14	3	11

E

11	14	3	6
8	9	16	1
10	7	2	15
5	4	13	12

F

7	12	1	14
2	13	8	11
16	3	10	5
9	6	15	4

G

5	1	12	16
10	14	3	7
15	11	6	2
4	8	13	9

H

4	1	13	16
14	15	3	2
11	10	6	7
5	8	12	9

I

2	15	1	16
11	10	8	5
14	3	13	4
7	6	12	5

J

1	7	14	12
10	16	5	3
15	9	4	6
8	2	11	13

K

1	2	16	15
13	14	4	3
12	7	9	6
8	11	5	10

L

1	8	10	15
14	11	5	4
7	2	16	9
12	13	3	6

M

1	13	4	16
8	12	5	9
14	2	15	3
11	7	10	6

N

1	14	4	15
8	11	5	10
13	2	16	3
12	7	9	6

O

1	11	6	16
14	13	4	3
7	2	15	10
12	8	9	5

P

1	15	14	4
12	6	7	9
8	10	11	5
13	3	2	16

for Jasper Johns

NUMBER SERIES (1966)
MEL BOCHNER

53

Number Series (Study for Magic Squares: Visually Random), 1967
Pen and ink and graphite on paper
17 3/8 x 22 1/4 in. (44.1 x 56.5 cm)
Collection Jasper Johns

take photo of all four AFA pieces

make a movie that is printed 8mm positive
on strips of paper

or

a still movie

find out about engraving or printing on acetate for
plexiglas

print photos like negatives — transparent
see through photos

completely document one piece — date of first sketch
size
kind of graph
places of exhibition
ans of models
materials
time
name of workmen
etc

make into large graph
complete with photos + photo of graph ~~drawing~~
then document the 'graph'

incomplete phenomenology

Untitled (Take Photos of All Four AFA Pieces), 1967
Graphite on lined paper
11 x 8½ in. (27.9 x 21.6 cm)

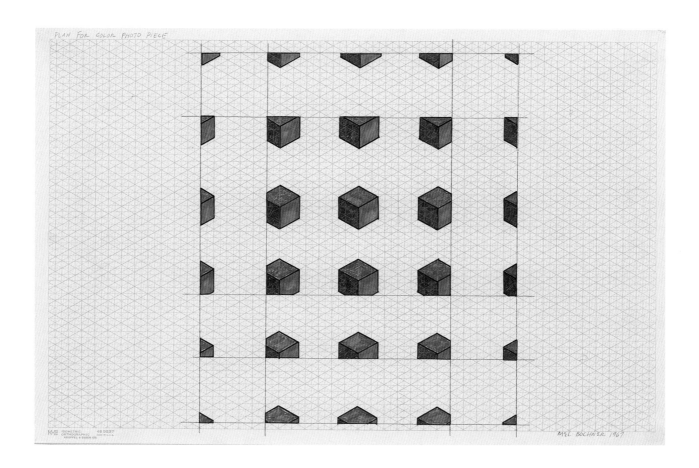

55

Plan For Color Photo Piece (Cuts), 1967
Pen and ink, watercolor, and graphite on graph paper
13 x 19 in. (33 x 48.3 cm)

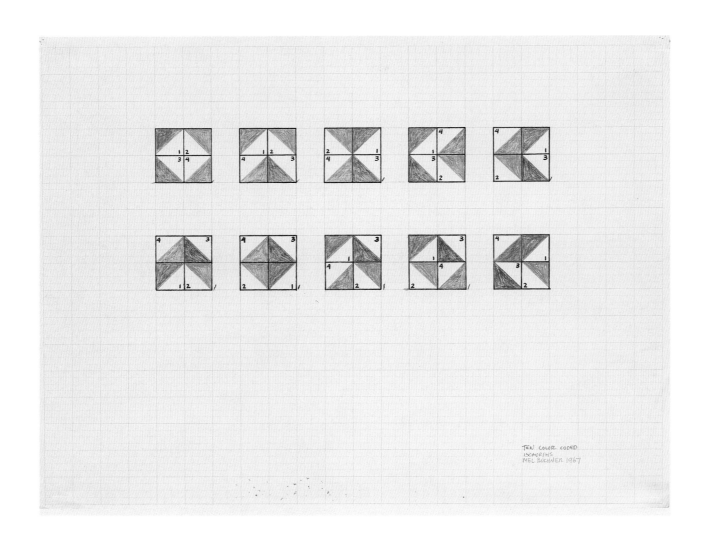

56

Ten Color Coded Isomorphs, 1967

Pen and ink and colored pencil on graph paper

17 3/4 x 22 1/2 in. (45.1 x 57.2 cm)

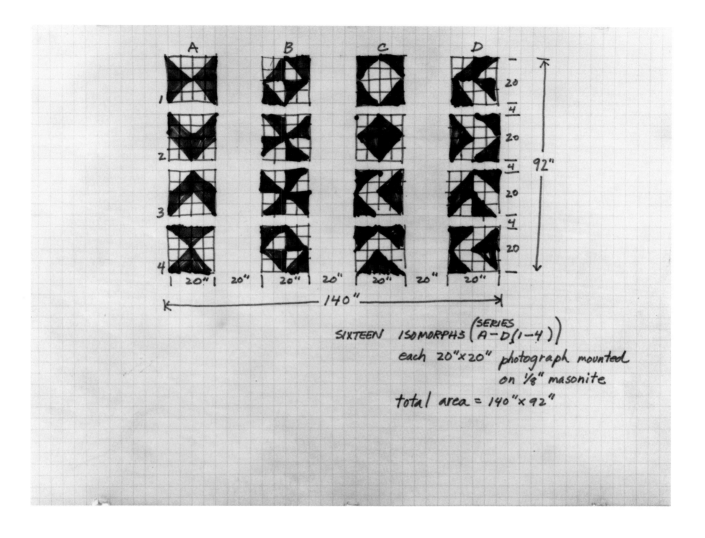

SIXTEEN ISOMORPHS (SERIES A−D (1−4))
each 20"×20" photograph mounted
on 1/8" masonite
total area = 140"×92"

Sixteen Isomorphs (Finch College Installation), 1967
Colored marker on graph paper
8 1/2 x 11 in. (21.6 x 27.9 cm)

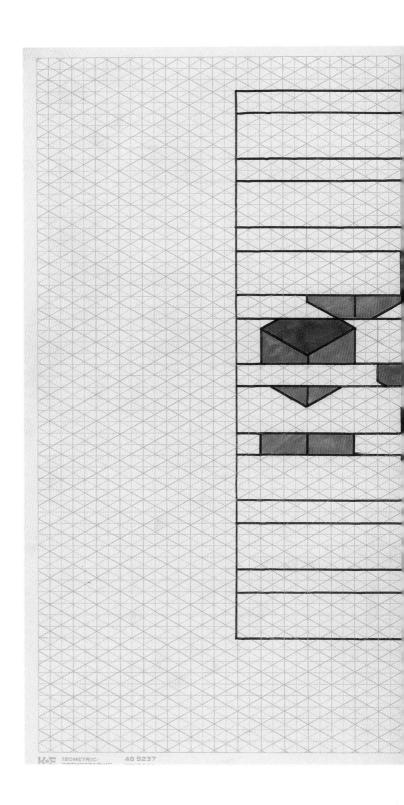

58

Constants and Variables: Horizontal Striations, 1967
Pen and ink on graph paper
13 x 19 1/16 in. (33 x 48.4 cm)

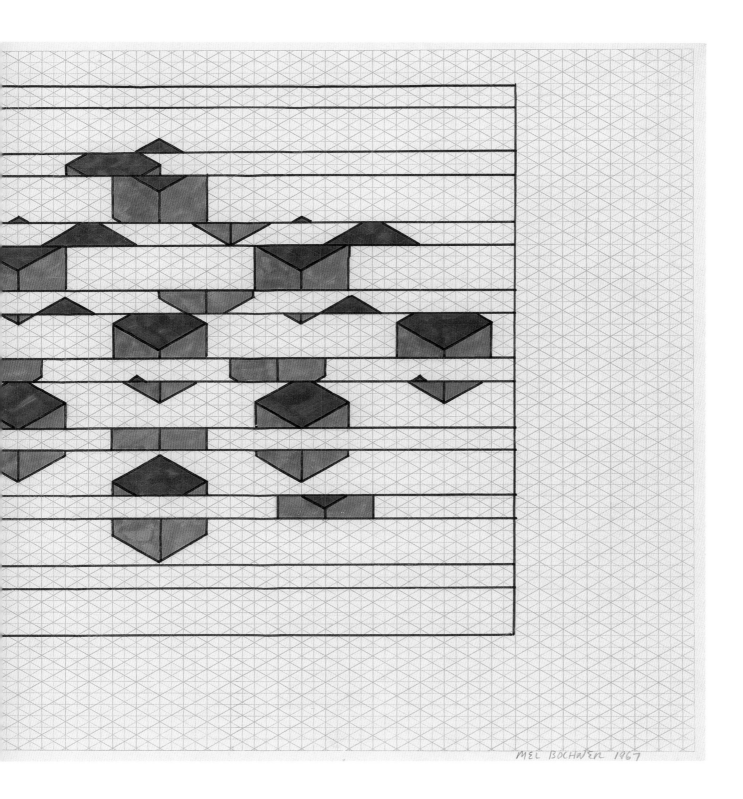

MEL BOCHNER 1967

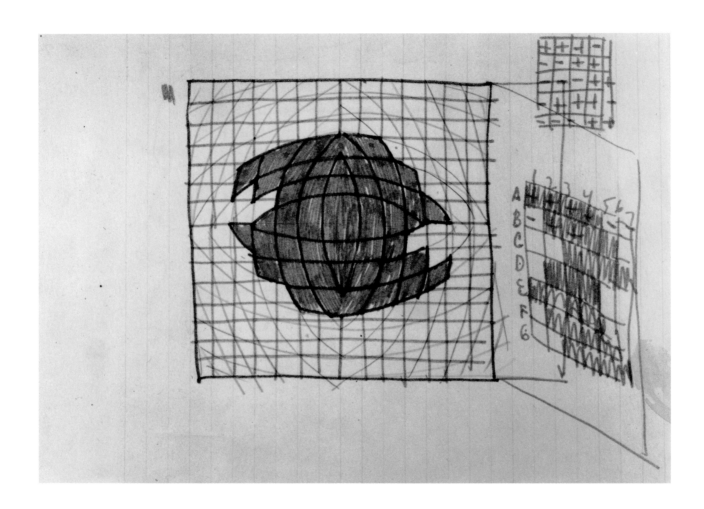

59

Untitled (Study For Constants and Variables:
Striations [Curved]), 1967
Colored marker on lined paper
7⁷/₈ x 10³/₈ in. (20 x 26.4)

60

Plan and Set for Photo Piece, 1967
Pen and ink and graphite on two sheets of graph paper
24 1/8 x 18 1/8 in. (61.3 x 46 cm)
Collection Cy Twombly

Twelve Sets (Visually Random), 1967
Photo collage on board
10 ⁵/₈ x 10 ¹/₂ in. (27 x 26.7 cm)

62

Study For Photo Piece (One Point Perspective), 1967
Pen and ink on graph paper
11 x 8 1/2 in. (27.9 x 21.6 cm)
Private Collection, Houston

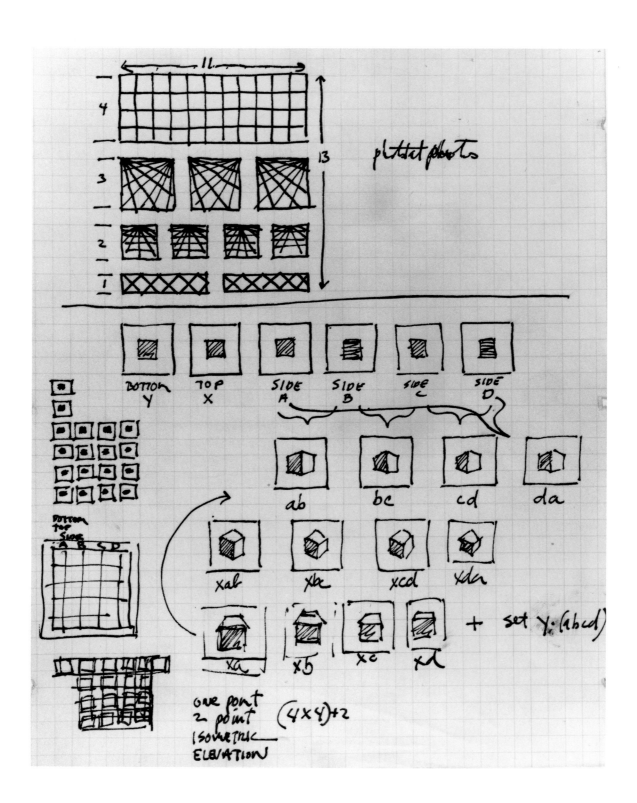

63

Untitled (Study for Multiple Perspective Pieces), 1967
Pen and ink on graph paper
11 x 8¹/₂ in. (27.9 x 21.6 cm)

64

Untitled (Study for One Point Perspective:
Four Orientations), 1967
Pen and ink on graph paper
11 x 8 1/2 in. (27.9 x 21.6 cm)

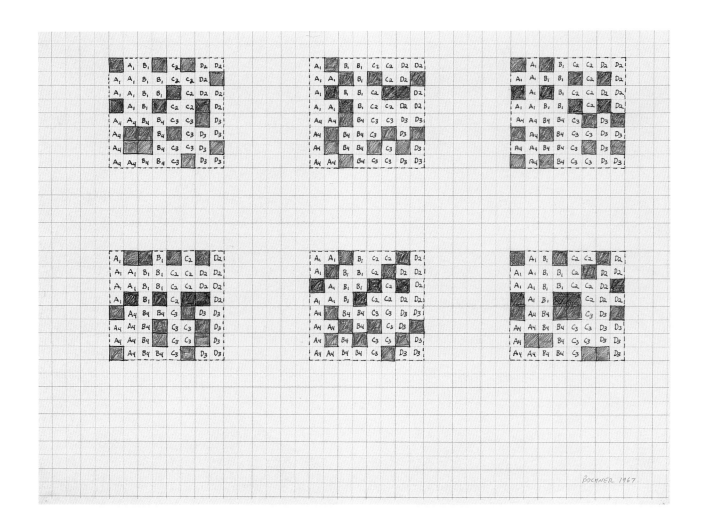

65

Six Diagrams for Dispersed Perspectives
(One Point), 1967
Pen and ink and colored pencil on graph paper
18 x 22 3/8 in. (45.7 x 56.8 cm.)

LAYOUT: SERIES 2
SET A (1967)
MB

66

Dispersed Perspective (One Point), 1967
Photo collage and graphite on board
17 x 17 in. (43.2 x 43.2 cm)

67

Untitled (Holes), 1967
Pen and ink on graph paper
11 x 8½ in. (27.9 x 21.6 cm)

deformation of
a surface across
a corner

deformation of
a surface from a
point

deformation

2 planes

3 planes

from 2 pts
in a plane

Untitled (Deformations), 1967
Pen and ink on graph paper
10 x 8 in. (25.4 x 20.3 cm)

69

Study for Disintegrating Crumples, 1968
Marker on graph paper
11 x 8 1/2 in. (27.9 x 21.6 cm)

70

Tracing (Surface Deformation): Recrumpled, 1967–68
Pen and ink on tracing paper
7 x 4⅝ in. (17.8 x 11.7 cm)

OPERATION 1:

ASHEET OF 48"x48"x½" MASONITE IS PAINTED FLAT WHITE AND LINED WITH ⅛" WIDE BLACK TAPE TO FORM AN OVERALL ORTHOGONAL GRID.

OPERATION 2:

THE FIRST NEGATIVE IS MADE WITH THE CAMERA POSITIONED 24" AWAY FROM + 24" ABOVE AN EDGE. FOR THIS SERIES (B) THE LENS ANGLE IS ▮. 45°.

Notes and Procedures: Photograph Series B/Part 2
(Study for Book), 1969
Pen and ink on graph paper, folded and stapled
8 ½ x 11 in. (21.6 x 27.9 cm) (each opening)

EMULSION —

— PHOTO
BACKING
PAPER

OPERATION 3:

A 24"x24" ENLARGEMENT OF
THE FIRST NEGATIVE IS PRINTED;
PHOTOGRAPH SERIES 'B'/PART 1
SINGLE POINT, 45° ELEVATION.

OPERATION 4:

ENLARGEMENT IS SOAKED OVERNIGHT
UNTIL EMULSION BEGINS TO SEP-
ARATE FROM BACKING. BACKING
IS THEN PEELED COMPLETELY FROM
EMULSION.

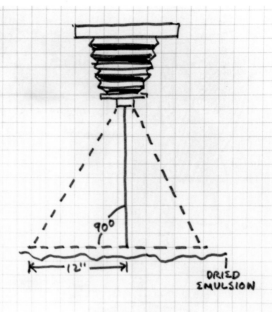

OPERATION 5

AFTER EMULSION HAS BEEN SEPARATED, IT IS HUNG BY TWO CLIPS IN A HIGH TEMPERATURE PHOTO DRIER TO DRY. NO ATTEMPT IS MADE TO REGULATED SHRINKAGE OR OTHER TOPOLOGICAL DISTORTIONS.

OPERATION 6:

COMPLETELY DRIED EMULSION IS REPHOTOGRAPHED WITH CAMERA LENS PERPENDICULAR TO THE PLANE OF THE EMULSION AT ITS CENTER.

1"x3" LUMBER

72"

PHOTO

HOMOSOTE

OPERATION 6:

ENLARGEMENT OF SECOND NEGATIVE
IS PRINTED 72" LONG AND WET
MOUNTED TO 1/8" THICK HOMOSOTE BOARD.
IT IS CUT TO SHAPE AND BACK WITH
1"X3" BOARDS FOR HANGING AND
SUPPORT.

OPERATION 8:

PIECE IS HUNG ONE INCH ABOVE
FLOOR LINE.

Untitled (Project Flat Image on Round Surface), 1968
Marker on graph paper
11 x 8 1/2 in. (27.9 x 21.6 cm)

insideout

corners

glass

shadow

shadows of
unidentified objects
cancellations

73

Untitled (Glass/Shadow), 1968
Marker on graph paper
11 x 8 1/2 in. (27.9 x 21.6 cm)

where a wall meets the floor (——)
where two walls meet (|)
where a wall meets the ceiling (——)
where two walls and the ceiling meet (·)
where the room begins (⌐¬)
where the sea meets the shore (~~~)
where the sea meets the sky (——)

wall | wall

wall | wall

| wall floor | wall | wall |
| ceiling wall | ceiling wall | wall |

ceiling wall | wall

continuous sea — discontinuous sky (time)

| wall floor | wall | wall |
| ceiling wall | ceiling wall | wall |

sea | shore · sky | sea
wall | ceiling · wall | wall
ceiling wall | wall · wall | wall floor
wall floor · door | wall

BOCHNER 1968

74

Untitled (Wall/Floor/Landscape, St. Martin), 1968
Ballpoint pen on tracing paper
8 ½ x 11 in. (21.6 cm x 27.9 cm)

75

Untitled (First Sketches for Measurement: Room)
(page from *The Singer Notes*), 1968
Ballpoint pen on graph paper
11 x 8½ in. (27.9 x 21.6 cm)

31

32

33

34

35

36

New York Windows:
A Spectacle of Anonymity

Elisabeth Sussman

Elisabeth Sussman

FIGS. 31–36 (opposite)
Mel Bochner and Robert Moskowitz,
Stills from *New York Windows*, 1966. 16-mm black-
and-white film.

In 1966, Mel Bochner and Robert Moskowitz collaborated on the making of a twelve-minute black-and-white film that they called *New York Windows*. Brimming with new ideas, the film is a series of durational episodes in which chance intervenes: incidents occur, but they are unplanned. They merely happen to happen. Contradicting the definition of motion picture as a continuum of moving images, the film looks like a series of still photographs. For each of the movie's ten segments, a stationary camera was set up and focused on a different storefront window. The only movement is registered on the windows by the reflections of passing cars and pedestrians. Occasionally, a distracted pedestrian passes in the space between the camera and the window. What is mesmerizing are the intersection of the things in the window displays with the formal properties of the camera's view, and the random action of the environment. While the structural issues of frame, duration, perspective, and chance are, on one level, what the film is about, the spectacle of urban life is a powerful subliminal text that constantly undermines the rigor of the structure.

The film swings between different types of views, some predominantly abstract and architectural, and others possessing an aura of commercialized desire. For instance, the first frames, shot from a medium distance, are of a window that is divided into three parts and that displays silver candlesticks and a coffee pot (fig. 31). While the camera is focused on this tableau, it picks up a passing car reflected in the window. Suddenly, between the fixed camera and the window, a woman dressed in hat and gloves walks across the field of vision, shattering a space that previously had not existed. The first section ends abruptly, and immediately the next window is in focus. In this sequence the frames of the window and camera are aligned, and the reflections in the window of trees and surrounding architecture fuse with the contents of the window: a sexy, aggressive fashion mannequin holding a whip and posed with jungle cats (fig. 32).

Two subsequent sequences are juxtaposed: in the first, the camera focuses downward on a long, rectangular window set in a marble facade; in

the second it focuses directly on a window in which there is an advertisement for a movie that shows a couple running (fig. 33)—a strong, readable image that is nonetheless broken by reflected bands of fluorescent lamps and the intermittent reflection of moving cars and pedestrians interrupting the field of vision. As in earlier sequences, the variation is not only in framing and point of view, but also in the presence—or absence—of the surrogate bodies of mannequins and advertisements.

Similar montages occur through the rest of the film. A sequence in which the camera is pointed at a curved glass facade captures the dematerialization of that facade by the distorted images of reflections of cars and by the reflection of the camera tripod itself (fig. 34). This sequence is soon followed by one of the window of a magazine shop (fig. 35), with the camera positioned close enough to reveal that the magazines on display are pornographic: mediated images that make explicit the subliminal sexual messages of the earlier mannequin. The film seems to grow progressively slower toward its close. In the next-to-last sequence, a window, behind which are hung rows of salamis and olive oil bottles, is filmed so close up that the objects overrun the frame of the camera (fig. 36). The film ends with a close-up of a derelict-looking shop with venetian blinds set behind the empty display area, an ending that feels both abstract and bleakly anonymous. All of this occurs in a filmic work that purposefully operates against the conventions of narrative film.

Bochner had come to New York in 1964 after studying art at the Carnegie Institute of Technology and philosophy at Northwestern University. Paintings he made that year reveal an interest in Jasper Johns, but by 1966 Bochner had abandoned painting and began to investigate serial concepts. For example, a work such as the sheet iron relief *One, Two, Three*, uses numerical order as its structuring principle: in its upper half, three rows of three projecting triangles are separated by spaces that expand by specific increments. As this piece indicates, Bochner was thoroughly engaged in his studio practice as an abstract artist. Other outlets for his thinking were teaching art history at the School of Visual Arts and writing for *Arts* magazine. It should not be surprising, given the diversity of his interests, that he would develop a wide range of media useful for the expression of his ideas, including film as both a medium and a theoretical tool. Moreover, it is important to note that Bochner chose to make films that were not abstract; rather, the images were charged with content. Along with a related 1968 magazine

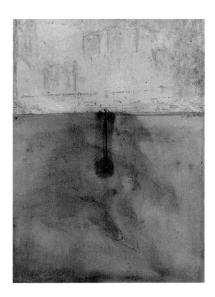

FIG. 37
Robert Moskowitz, *Untitled*, 1961.
Collage, glue, and pigment on canvas. 54 x 39 1/2 in.

work, "Alfaville, Godard's Apocalypse" (designed by the artist), *New York Windows* is a highlight of Bochner's idiosyncratic genre: a hybrid work that interweaves theory, content, and materiality.[1]

Bochner's work came to fruition in the mid-sixties, as interest in photography flowered and alternative and commercial filmmaking experienced a renaissance that was particularly represented by the New Wave filmmakers from France. Both Bochner and Moskowitz were also interested in the more traditional documentary branch of photographic practice through links to Walker Evans. In May 1966 Moskowitz had worked as Evans's assistant on a book project photographing nineteenth-century architecture of the mid-Hudson Valley.[2] Bochner bought a print, *Penny Picture Display, Savannah* (1936), from Evans's 1966 one-person show at the Robert Schoelkopf Gallery.[3] Bochner and Moskowitz met in 1965 while Bochner was working as a guard at the Jewish Museum. The following year, when an acquaintance let them borrow a movie camera with seventy-two seconds of unexposed film remaining in the magazine, they decided to try making a movie. Their first attempt, *Walking a Straight Line Through Grand Central Station* (seventy-two seconds long), was shot in the train station during rush hour. The artists used a simple strategy: they pointed the camera forward and tried to maneuver their way in a straight line, from one side of the station to the other. But the bombardment of jostling commuters made this impossible. The emphasis in this film is on a single discrete action that is undermined by chance. The simple banality of the concept resembles the ideas for a new dance structured around everyday activity, which was being developed at the Judson Church by Yvonne Rainer, Steve Paxton, and others. But its urban setting and structural rigor led Bochner and Moskowitz in a different direction.

The imagery of their second film, *New York Windows*, is clearly related to the paintings of Moskowitz. His interests at this point were interior architecture and windows as concrete beginnings for ultimately mysterious pictorial spaces. Moskowitz's early paintings, which he had shown at the Leo Castelli Gallery in 1962, had actually incorporated window shades (fig. 37). In the early sixties he began a series of monochromatic paintings of a corner of a room, paintings that hovered between abstraction and representation. "My work from the 1960s," Moskowitz has written, "was involved with an architectural type of space that evolved into a symmetrical corner space."[4] For Moskowitz, the film of urban windows was not psychologically motivated. Ultimately, what made the project interesting were the chance incidents that are inherent in photography,

the events—such as unpredictable reflections in windows—that simply happen beyond the control of the filmmakers.

If Moskowitz enjoyed the chance and randomness of filmmaking, Bochner was interested in film's conceptual possibilities. Though the filmed work is the only exhibited manifestation of Bochner's thinking about *New York Windows*, other forms of his thoughts—drawings and texts—should also be considered part of the work. In fact, the notes and drawings could have been shown in the exhibition that he organized in the same year, *Working Drawings And Other Visible Things On Paper Not Necessarily Meant To Be Viewed As Art.*[5] That exhibition (considered by some to be the first work of Conceptual art) consisted of four loose-leaf notebooks, each with one hundred copies of other artists' studio notes, working drawings, and diagrams collected and photocopied by the artist and displayed on four pedestals. The notion of "working drawings" suggests that the concept or plan is as important as the finished "work of art." Bochner's schematic 1966 drawing for *New York Windows* (fig. 38) possesses an attractive economy and clarity: on graph paper are nine drawn squares, which stand for the sequential views of nine windows that compose the first edit of the film. Each square contains the same information: a diagram of the relationship between the frames (camera and window), the length of the take, and the distance from the camera lens to the window plane. Beneath the window diagrams is a list of simple facts in categories: camera, contents of the window, lens position, etc. Bochner's written notes are more discursive and theoretical:

The film is about still photos; The "cut" breaks time, destroying the illusion of a natural sequence between events; stationary camera and the static object—Warhol's films; no attempt at naturalism is made; everything has been pre-framed; the camera was set up in front of and perpendicular to the window; camera was wound up and allowed to wind down by itself; in some cases the window frame is identical to the film frame; in other cases the window frame is just outside or inside; the windowpane, now congruent with the movie screen becomes the debased counterpart of the painter's picture plane, simultaneously transparent and reflective; nothing moves except in reflection; film shot at 24 fps and projected at 16 fps; occasional passer-by moves between the camera and the window shattering the last believable vestige of space; only sound is the projector whirring.[6]

These notes and other similar ones (figs. 39–40), as well as the drawing, were completed while the film was being edited in the spring of 1966. Bochner's

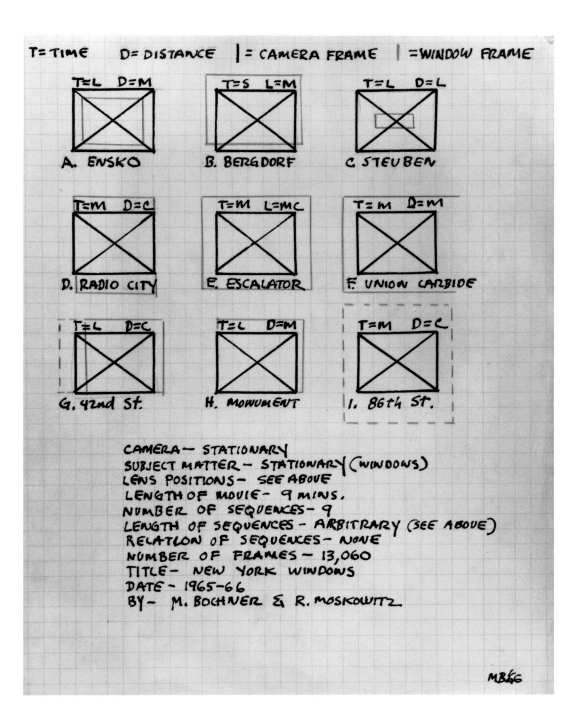

T=TIME D= DISTANCE | = CAMERA FRAME | =WINDOW FRAME

T=L D=M
A. ENSKO

T=S L=M
B. BERGDORF

T=L D=L
C. STEUBEN

T=M D=C
D. RADIO CITY

T=M L=MC
E. ESCALATOR

T=M D=M
F. UNION CARBIDE

T=L D=C
G. 42nd St.

T=L D=M
H. MONUMENT

T=M D=C
I. 86th St.

CAMERA— STATIONARY
SUBJECT MATTER— STATIONARY (WINDOWS)
LENS POSITIONS— SEE ABOVE
LENGTH OF MOVIE— 9 MINS.
NUMBER OF SEQUENCES— 9
LENGTH OF SEQUENCES— ARBITRARY (SEE ABOVE)
RELATION OF SEQUENCES— NONE
NUMBER OF FRAMES — 13,060
TITLE— NEW YORK WINDOWS
DATE— 1965-66
BY— M. BOCHNER & R. MOSKOWITZ

MB66

*spectacle
anonymity*

photography to Proust
was itself the product
of complete alienation

. most attitudes toward film originate
from the slice-of-life novel. Terminology
tends to duplicate Terminology: subject, motion,
episode.

"I want to reproduce the objects as they are, or as
they would be even if I did not exist" Taine

the characteristic of incompleteness
the provisional limits of the frame. No definition
or interpretation.

Early names for film give clues to
the aspirations — vitascope, vitagraph, bioscope
biograph — a desire to record "life." & the
craze involvement with movement & terms like
kinetoscope, kinetograph & cinematograph.
Film can attain a remarkable dispassionate
anonymity. The provisional limits of the frame,
the single eye focus give it its major characteristic
of incompleteness. The filmmaker chooses, he does
not compose. Elements within the rectangular
frame remain mostly to themselves + unaware as
they relate to four sides + four right angles.
Film can easily satisfy the demand of Brecht's
alienation effect. It can be broken at any
time. It progress discontinuously. All watching
illusion of motion. Flatness. The film is flat
because it exhibits a lower degree of solidity
than binocular vision. Natural objects has
disparate importance.

FIG. 39

Mel Bochner, *Untitled Notebook Page
(Spectacle/Anonymity)*, 1966. Pen and ink and
ballpoint pen on lined paper,
11 x 8½ in. (27.9 x 21.6 cm). Collection of the artist

Working Drawings exhibition opened on 2 December 1966, and four days later *Projected Art*, an exhibition devoted to artists' films and installations using film, opened at the Finch College Museum. A broad range of films were screened, including historic (Hans Richter, Oskar Fischinger, Joseph Cornell, for instance) and contemporary (Ed Emshwiller, Don Pennebaker, Robert Breer). The installations were by Stan Vanderbeek, Robert Whitman, Andy Warhol, Dan Graham, and Herbert Gesner. Elayne Varian, the director of the Finch College Contemporary Study Wing who curated the show, acknowledged in her notes "the growing awareness of filmmaking as an art form" and "the increasing number of non-professionals" who had been "attracted to the medium." "These film artists," Varian wrote, "break all technical rules and put aside logical development, meaning and purpose, because they are reacting against the cinema of personal relationships and the commercial superficial smoothness of the films produced as mass media."[7] *New York Windows* had its first public screening as part of the *Projected Art* program.

Bochner and Moskowitz's technique could be compared to Chris Marker's *La Jetée*, a science fiction parable made in France in 1962 in which the narrative unfolds in a series of visions conveyed by single images—like changing slides in a slide show—barely linked in the editing to achieve a narrative flow. Like Marker's film, *New York Windows* is a sequence of images but, unlike Marker's film, it succumbs to no narrative. Purely formal sections in which the interest is on framing, or on chance reflections or movements, are interspersed with windows where the focus dwells on the commercial spectacle of products—lines of grocery items or a display of soft-core pornographic magazines. These filled shop windows have antecedents in still photography, with Atget and Walker Evans being the best-known examples. But *New York Windows* flips this still photography tradition into film. It thus inserts itself into a particular history of film: films of New York.

As such, *New York Windows*, given the facts of its production and distribution, must be differentiated from the great neo-noir productions of the 1950s, like *The Sweet Smell of Success*, and compared to 1950s antecedents such as Stan Brakhage's *The Wonder Ring* (shot from an above-ground subway train) and Shirley Clarke's *Bridges Go Round* (a series of film loops of the bridges around Manhattan). In these films camera movement is a metaphor for the kineticism of urban life. But *New York Windows*, in which the movie camera is treated simply as a dumb instrument, turned on and off and pointed in one direction for a specific length of time, during which nothing planned

170

FIG. 40

Mel Bochner, *Untitled Notebook Page*
(It's The Emptiness . . .), 1966. Graphite and
ballpoint pen on lined paper,
11 x 8½ in. (27.9 x 21.6 cm). Collection of the artist

happens, conveys a "zero degree," a stasis, at the heart of the metropolis. In this respect it is closest in spirit to the sixties experimental tradition of New York films, particularly Warhol's *Empire* (1964), which is "cinema verité"—informed by the idea that what was filmed in real time was somehow "true." In *Empire* the camera holds a single view of the Empire State Building for eight hours. The ostensible subject is duration, and the passage of time is the only "action" of the film. The viewer, lulled or bored, is in a meditative state. Superficially, *New York Windows* resembles *Empire*. The subject is unitary— shop windows—and the method is the same throughout—the fixed camera. But by contrast, there is no continuous real time, or real space, either. Like the Lacanian analysis that is interrupted before closure, *New York Windows* subverts closure. Disclosing that film is a lie, a conscious fabrication of flow, *New York Windows* is harshly discontinuous, broken, artificial. The individual sequences, though on the same length of film, are abruptly terminated, differ from section to section in camera perspective, and, denying expectations, unlinked in narrative flow.

New York Windows* is, in many ways, a work that conforms to Rosalind Krauss's description of Minimalism: "For this generation [the sixties] the mode of expression became the deadpan, the fixed stare, the uninflected repetitious speech, or rather, the correlative for these modes were invented in the object-world of sculpture."[8] But there is another reading. We must take into account certain qualities of the film—its attention to the reflectivity of the surfaces of midtown Manhattan buildings, the variety of commercial spectacle in the windows, the layered simultaneous appearance of cars and pedestrians—which give this "deadpan" cinema its allegorical feeling. Among other descriptive notes in his 1966–67 unpublished text on the making of *New York Windows*, Bochner writes that windows were chosen on the basis of the artificiality of their displays and for their hard, smooth surfaces. "*New York Windows*," he writes, "is a spectacle of anonymity, the emptiness that overruns and fills-up everything."[9]

These words carry an existential ring and probably reflect Bochner's engagement with ideas embedded in the films of Jean-Luc Godard. Bochner was an avid filmgoer. By his own account, it was the films of Godard, one of the leading artists of the French New Wave, that impressed him most deeply.[10] Godard worked against the grain of narrative, to reduce the comfort level of normal spectatorship, but he retained the tropes of traditional—particularly Hollywood—genres by playing off their stereotypes. Still, there was a seri-

Alfaville,
Godard's Apocalypse

by MEL BOCHNER

"Torpor is the enemy."—Eca de Quieroz

A centrally located circular light, too intense to look at, blinks on and off at regular intervals. The sound track opens in a raspy, monotone:
"Sometimes . . . reality . . . is . . . too . . . complex . . .
Fiction . . . gives . . . it . . . form . . ."

"In a series of pictures he transforms the nothingness of listless and uniform days into an oppressive condition of repugnancy, boredom, false hopes, paralyzing disappointments and piteous fears. Nothing happens but that nothing becomes heavy—a grey and random human destiny moving towards its end." Erich Auerbach on Flaubert's Madame Bovary.

Alphaville Locations: Deserted lobbies, parking lots, shopping plazas, cloverleaf intersections, curtain-wall buildings, self-service elevators, hotel bathrooms, phone booths, circular staircases, highways around large cities, a bedroom with a juke box.

"My movies are blocks."—Jean-Luc Godard.
CAST:
Lemmy Caution........Eddie Constantine
Natasha von Braun..........Anna Karina
Henri Dickson..............Akim Tamiroff

Alfaville ——— society of the present-future ——— ruled by a mad physicist ——— outcast from earth ——— governed by a computer, "Alfa 60," which acts always in the "common good" ——— phenomena maintained by a "crisis constant" ——— the state provides strangers with women ——— anxiety as an operational value ——— behaviorism ——— drive–cue–response–reward ———. For Alfa 60 the boundary of life is language———. "There is nothing else to experience except words; as long as words keep their meanings and meaning its words" ——— political executions are carried out in a swimming pool.

Natasha and Lemmy suffering dumbly from certain external and unintelligible strains.

Lemmy: This book you call The Bible . . . it's a dictionary.
Natasha: *Is there a difference?*

"Logic pervades the world:
the limits of the world
are also its limits."
—Wittgenstein

*If words define experience, then behavior becomes subject to the problems of language . . . tautology, conundrum, diffusion, paradox, ambiguity, contradiction, vicious circle.
Words are suspect, the dictionary is altered at the whim of the "authorities," convention collapses. Communication ceases. Thought becomes impossible. Symbols separate from their assigned meanings, questions go unanswered, answers go unquestioned, words substitute for action. Action becomes impossible. Stasis.*

Wherever Lemmy Caution goes he takes snapshots with a Kodak Instamatic Camera and flashcube attachment.

A sign caught in the headlights:
LOGIC: SILENCE

Surfaces: A. The film
coarse, grainy, uneven, pocked.
B. Object matter
hard, brittle, smooth, reflective.
1. transparent
glass, plexiglas.
2. opaque
stainless steel, poured concrete, aluminum, formica, chrome.

Eddie Constantine is numbed by a powerful sottishness as he moves down the labyrinthian corridors of Alfaville. His mind is sluggish and opaque. Lassitude. His face is parched and immobile. His body heavy, virtually stagnant. His reactions slow and tepid, he acts, it seems, out of nothing more than a slightly roused boredom. His avowal of humanist values such as love and personal feeling are all the more disproportionate.

"Perhaps all pleasure is only relief."
—William Burroughs
"There seems a certainty in degradation."
—T. E. Lawrence
"The love of life is the kiss of death."
—Ad Reinhardt
"If you look at something long enough, I've discovered that the meaning goes away."—Andy Warhol

"Once we have devised computers with a genuine capacity for self-improvement, a rapid evolutionary process will begin. As the machine improves both itself and its model of itself, we shall begin to see all the phenomena associated with the terms 'consciousness,' 'intuition' and 'intelligence' . . . it is unreasonable to think machines

could become nearly as intelligent as we are and then stop, or to suppose we will always be able to compete with them. Whether or not we could retain some sort of control of the machines, assuming that we would want to, the nature of our activities and aspirations would be changed utterly by the presence on earth of intellectually superior beings."—M. L. Minsky

Shots: A. Frames
cut off, casual, often missing the action, static, exaggerated angles (in the manner of TV news coverage), discontinuous.
B. Tonality
washed-out grays over- or under-exposed, random negative footage, irregular patches of extreme dark or light.

Godard as the Law.

Systems of tentative paralysis.

On the perimeter of the city live those who cannot conform. In this gray zone Lemmy locates his old friend Henry Dickson, a fellow "Outlander," living in a sleazy hotel. On the stairs Lemmy asks, "Is Dick Tracy dead? Is Flash Gordon still alive?" Once inside the dilapidated room he is forced to hide behind a chest of drawers while a beautiful, scantily clad girl (a state prostitute and spy) offers herself to the old man. While engaged in preliminary love-making, the old man is seized by a heart attack. His last words to Lemmy: "Save those who weep."

The implications of Alphaville are moralistic. Godard opts for humanist values in the context of his projection of "technologism." He sees Alphaville as present and apocalyptic. The erasure of individuality and personality, or what Lemmy Caution calls "poetry," he views as tragic. Godard's "sociology" is exceedingly romanticized. Man has already been displaced from the center of the universe.

"You must never say why; only because."
—Natasha von Braun

"Time is a circle, the descending are is the past, the ascending are the future, there is only the present."—Alpha 60
"Time is never a corruption or even a catastrophe, but merely a change of place, a hideout for data."—Roland Barthes

FIG. 41

Mel Bochner, *Alfaville, Godard's Apocalypse (Project for a Magazine)*, 1968.
Published in *Arts Magazine* (May 1968)

Barriers of reflection.

"Parking lots." Ed Ruscha, photo/Aeanis.

In Alphaville there is no time. The clock is a circle and time is the measurement of the movements on its "face." "Before" in relation to "after" is the character of time. "Before" and "after" are divisions of "time" separated by "now." But "now" as a "part" of time is unavailable. It has no duration, and the bleak search for the "present" becomes the interminable "past." At that juncture time stops.

"The movies are a world of fragments."
—Jean-Luc Godard

Political executions are carried out in the swimming pool. The person to be executed, hands tied, is led to the edge of the diving board. Around the balcony various officials look on. The condemned man generally makes a short speech about freedom, existence or human solidarity. The strange hollow sound of his words is punctuated by a burst of machine-gun bullets. After he falls into the water, a bevy of girls gracefully dive in after him and, if necessary, fiinish the execution with knives.

Catatonia in the "Capital of Pain."

Phenomena of consciousness.

Alias William Burroughs.

Godard's eschatology is conventional within the tradition of "crisis" literature and art of the twentieth century. Yeats, Pound, Wyndham Lewis, all envisioned the Apocalypse and an ensuing "renovation out of decadence." They confronted it with the posture of authoritarianism; the Surrealists, in turn, preferred pseudo-anarchism. More recently, artists such as Warhol have presented an attitude of passivity. In his movies Warhol demonstrates a preoccupation with the more fictive elements of "crisis" by presenting everything as stereotype. Even more interesting than Warhol are the movies of Roger Corman, especially his *Wild Angels*. Unlike Godard, he makes no assessments of the "contemporary malaise"; his concern is only with appearances and the surface of things. The *Wild Angel* motorcyclists are complete fabrications, only tangentially based in fact. When Corman's characters speak, motives do not exist. Nancy Sinatra, a motorcycle gang girl, in reply to her boyfriend's question "How have I changed?" says, "I don't know . . . it's just kinda weird." The audience is distanced by banality and what Brecht refers to as the "alienation effect." Godard, on the other hand, eschews the artificial and attempts to portray believable human feelings. **He** asks that we forego theatricality and believe emotionally in the plight of a "hero" and "heroine" who are themselves in a state of disbelief.

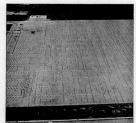

Barriers of reflection.

"Parking lots." Ed Ruscha, photo/Aeanis.

In Alphaville there is no time. The clock is a circle and time is the measurement of the movements on its "face." "Before" in relation to "after" is the character of time. "Before" and "after" are divisions of "time" separated by "now." But "now" as a "part" of time is unavailable. It has no duration, and the bleak search for the "present" becomes the interminable "past." At that juncture time stops.

"The movies are a world of fragments."
—Jean-Luc Godard

Political executions are carried out in the swimming pool. The person to be executed, hands tied, is led to the edge of the diving board. Around the balcony various officials look on. The condemned man generally makes a short speech about freedom, existence or human solidarity. The strange hollow sound of his words is punctuated by a burst of machine-gun bullets. After he falls into the water, a bevy of girls gracefully dive in after him and, if necessary, fiinish the execution with knives.

Catatonia in the "Capital of Pain."

Phenomena of consciousness.

Alias William Burroughs.

Godard's eschatology is conventional within the tradition of "crisis" literature and art of the twentieth century. Yeats, Pound, Wyndham Lewis, all envisioned the Apocalypse and an ensuing "renovation out of decadence." They confronted it with the posture of authoritarianism; the Surrealists, in turn, preferred pseudo-anarchism. More recently, artists such as Warhol have presented an attitude of passivity. In his movies Warhol demonstrates a preoccupation with the more fictive elements of "crisis" by presenting everything as stereotype. Even more interesting than Warhol are the movies of Roger Corman, especially his *Wild Angels*. Unlike Godard, he makes no assessments of the "contemporary malaise"; his concern is only with appearances and the surface of things. The *Wild Angel* motorcyclists are complete fabrications, only tangentially based in fact. When Corman's characters speak, motives do not exist. Nancy Sinatra, a motorcycle gang girl, in reply to her boyfriend's question "How have I changed?" says, "I don't know . . . it's just kinda weird." The audience is distanced by banality and what Brecht refers to as the "alienation effect." Godard, on the other hand, eschews the artificial and attempts to portray believable human feelings. **He** asks that we forego theatricality and believe emotionally in the plight of a "hero" and "heroine" who are themselves in a state of disbelief.

ousness in Godard's filmmaking—a philosophical stance that contained a condemnation of contemporary society. Godard's films can display through the physical environment the horrors of modernity.[11] Is this where Bochner's "anonymity"—the look of the urban environment of *New York Windows*— comes from? But Godard's view of modernity, embedded in imagery and bogged down by discourse was, for Bochner, too literary. Bochner's article "Alfaville, Godard's Apocalypse" for an issue of *Arts* was published, coincidentally, in May 1968 at the moment of the Paris student uprisings, which were to alter Godard's filmmaking so fundamentally (fig. 41). The article, departing from the usual columns of text typical of magazine layout, is more of a montage, like *New York Windows*, with discrete units positioned in relation to one another. In this four-page illustrated article Bochner divides each page into blocks, usually three across and four down. "My films are blocks," Bochner quotes Godard as saying. Each page has one or two horizontal sections of photographs. The other blocks are filled with text. The reader can move on the page in any direction; sometimes the text extends over several blocks. Bochner embeds an argument against Godard's moralism interspersed in a variety of texts and images. He suggests that Roger Corman's film *Wild Angels* is more direct, less pretentious in capturing the "contemporary malaise" by keeping in the foreground a concern "with appearances and the surface of things."[12] Among the images included are stills from *Alphaville* and *Wild Angels*, and a photograph by Ed Ruscha of a parking lot. Other illustrations are of action scenes with people (including William Burroughs with a gun) and of urban scenes: a traffic jam and a modernist parking garage. The text blocks include *Alphaville* film credits, texts by Bochner about language, flat descriptions of *Alphaville* settings, the textures of the film, and the types of shots. These are interspersed with quotes attributed to Wittgenstein (on language), Barthes (on time), Marvin Minsky (on computers), Erich Auerbach (on *Madame Bovary*), and Brecht (on the alienation effect).

The layout of Bochner's magazine piece is like *New York Windows* in that no one narrative predominates: breaks and discontinuities undermine any extended involvement with individual blocks of thought, or, in the case of the film, images. Bochner undermines the "apocalypse" of Godard. We know that Bochner, unlike Godard, does not at all want the viewer to be involved with atmosphere. Rather, he wants the viewer to recognize the structural approach to film that he pursued. Bochner was more interested in the breakdown of film's purported naturalism, and, in this regard, was intellectually allied

with the contemporaneous film criticism of the British writer Peter Wollen, who approached narrative film from a structuralist point of view. "For realist aesthetics," Wollen wrote, "the cinema is the privileged form which is able to provide both appearance and essence, both the actual look of the real world and its truth. . . . In fact, this aesthetic rests on a monstrous delusion; the idea that truth resides in the real world and can be picked out by a camera."[13] For Bochner, film is a physical material, passing through a camera and subjected to light. These facts about the material and process include the possibility of order (the technical handling of the film and camera) and its opposite —disorder. Any allegorical details, any "anonymity" to which Bochner alludes an interest, has to emerge through the structural elements—the focus, the framing—in the process of filming and editing and not through the literary narrative of traditional filmmaking. Thus, the dystopian view that lurks in the word "anonymity," used to describe *New York Windows*, emerges from the process of making the film, the concentration on the specific language of that medium.

Bochner subsequently initiated similar investigations of the language of each medium he came to use—painting, sculpture, photography. The results were surprising new things, like *New York Windows*, in which the structure of film hitherto sublimated is unmasked and the properties that seemed "natural" are ignored.

Notes

1 "Alfaville, Godard's Apocalypse," *Arts Magazine* 42 (May 1968): 14–17. The title of Godard's film *Alphaville* was incorrectly typeset by *Arts Magazine*.

2 Author's telephone interview with Robert Moskowitz, 2000.

3 Sasha Newman, "The Photo Pieces," in Richard S. Field, *Mel Bochner: Thought Made Visible 1966–1973* (New Haven: Yale University Art Gallery, 1995), 117.

4 This statement is found in the artist's file at The Museum of Modern Art library, New York.

5 The exhibition was held at the School of Visual Arts Gallery, New York, 2–23 December 1966.

6 Bochner's notes were written in 1966–67; therefore, they were completed after the film was finished. The notes are unpublished and were made available by Bochner.

7 Varian's comments were in her "Foreword and Acknowledgement" included on the brochure for the exhibition *Projected Art*, which opened in December 1966 at the Contemporary Study Wing, Finch College Museum of Art, 62 East 78th St., N.Y.

8 Rosalind Krauss, "LeWitt in Progress," in Krauss, *The Originality of the Avant-Garde and Other Modernist Myths* (Cambridge: The MIT Press, 1997), 258.

9 The text was provided by Mel Bochner.

10 Conversation with the author, 1999.

11 For a discussion of Godard's *Alphaville*, where a science-fiction, film noir tradition is evoked in the service of political/philosophical critique see Dixon Wheeler Winston, *Godard* (Albany: State University of New York Press, 1997), 58–64.

12 All quotes are from the text of Bochner, "Alfaville, Godard's Apocalypse."

13 Peter Wollen, *Signs and Meaning in the Cinema* (Bloomington: Indiana University Press, 1972), 165–66.

Checklist of the Exhibition

36 Photographs and 12 Diagrams, 1966
PLATE 1
36 gelatin silver prints and 12 pen-and-ink
drawings mounted on board
8 x 8 in. (20.3 x 20.3 cm) each panel; 73 x 55
in. (185.4 x 139.7 cm) overall
Collection Städtische Galerie im Lenbachhaus,
Munich

3 Photographs and 1 Diagram (Row H),
1966–67/2001
PLATE 2 (catalogue image from
alternate source)
4 gelatin silver prints mounted on board
20 x 20 in. (50.8 x 50.8 cm) each panel;
90 x 20 in. (228.6 x 50.8 cm) overall

H-2, 1966–67
PLATE 3
Silhouetted gelatin silver print mounted on
Masonite
45$^{1}/_{4}$ x 45$^{1}/_{4}$ in. (114.9 x 114.9 cm)

H-3, 1966–67
PLATE 4
Silhouetted gelatin silver print mounted on
Masonite
46$^{1}/_{4}$ x 79$^{1}/_{2}$ in. (117.5 x 201.9 cm)

Photograph-Blocks (Four by Four), 1967
PLATE 5
4 gelatin silver prints mounted on board
12$^{1}/_{4}$ x 12$^{1}/_{4}$ in. (31.1 x 31.1 cm) each panel

Four Comments Concerning:
Photograph-Blocks, 1967
PLATE 6
Photostat mounted on board
12$^{1}/_{4}$ x 12$^{1}/_{4}$ in. (31.1 x 31.1 cm)

None Tangent, 1967
PLATE 7
Gelatin silver print cut into 16 parts and
mounted on Masonite
10 x 10 in. (25.4 x 25.4 cm) each panel;
44 x 44 in. (111.8 x 111.8 cm) overall

Sixteen Isomorphs (Negative), 1967
PLATE 8
16 gelatin silver prints mounted on board
19$^{1}/_{2}$ x 19$^{1}/_{2}$ in. (49.5 x 49.5 cm) each panel;
89 x 140 in. (226.1 x 355.6 cm) overall

Isomorphic Circles (Compass #1):
Negative, 1967
PLATE 10
Gelatin silver print mounted on Masonite
29$^{1}/_{2}$ in. (39.4 cm) diameter

Magic Squares (Visually Random #1)
A & B, 1967
PLATE 11
2 gelatin silver prints
19$^{1}/_{4}$ x 19$^{1}/_{4}$ in. (48.9 x 48.9 cm) each

Perspective: One Point (Positive), 1967
PLATE 12
Gelatin silver print mounted on Masonite
49 x 47$^{1}/_{2}$ in. (124.5 x 120.7 cm)
Collection Städtische Galerie im
Lenbachhaus, Munich

Perspective: Two Point (Negative), 1967
PLATE 13
Gelatin silver print mounted on Masonite
48 x 70$^{1}/_{2}$ in. (121.9 x 179.1 cm)

Perspective Insert (Two in One), 1967
PLATE 14
Gelatin silver print mounted on Masonite
48 x 48 in. (121.9 x 121.9 cm)

Perspective Insert (Two in One, Pink), 1967
Dyed photograph mounted on Masonite
8 x 8 in. (20.3 x 20.3 cm)

Perspective Insert (Two in One, Green), 1967
Dyed photograph mounted on Masonite
8 x 8 in. (20.3 x 20.3 cm)

Convex Perspective, 1967
PLATE 15
Silhouetted gelatin silver print mounted
on Masonite
45$^{1}/_{2}$ x 27$^{1}/_{4}$ in. (115.6 x 69.2 cm)
Collection David Nolan and Carol Eckman,
New York

Dispersed Perspective (One Point):
R. W. B., 1967
PLATE 16
Spray lacquer on gelatin silver print cut into
16 parts and mounted on Masonite, and
graphite on wall
10 x 10 in. (25.4 x 25.4 cm) each panel;
80 x 80 in. (203.2 x 203.2 cm) overall

Warp (#1), 1967
PLATE 17
Gelatin silver print
10 x 8 in. (25.4 x 20.3 cm)

Warp (#2), 1967
PLATE 18
Gelatin silver print
8 x 10 in. (20.3 x 25.4 cm)

Perspective Insert (Collapsed Center), 1967
PLATE 19
Gelatin silver print mounted on board
48 x 48$^{1}/_{2}$ in. (121.9 x 123.2 cm)

Surface Deformation, 1967
PLATE 20
Gelatin silver print mounted on Masonite
30 x 20 in. (76.2 x 50.8 cm)

Surface Deformation (Green), 1967
PLATE 21
Fabric dye on Photostat
11 x 7$^{5}/_{8}$ in. (27.9 x 19.4 cm)

Surface Deformation (Orange), 1967
PLATE 22...

Surface Deformation (Orange), 1967
Fabric dye on Photostat
11 x 7$^{5}/_{8}$ in. (27.9 x 19.4 cm)

Surface Deformation/Crumple, 1967/2000
PLATE 22
Gelatin silver print mounted on aluminum
52 x 28 in. (132.1 x 71.1 cm)
Collection Suzanne Cohen, Baltimore

Crumple, 1967/1994
PLATE 24
Silhouetted silver dye bleach print (Ilfochrome)
mounted on board
31$^{1}/_{2}$ x 15 in. (80 x 38.1 cm)

Surface Dis/Tension, 1968
PLATE 25
Silhouetted composite gelatin silver print
mounted on board
72 x 68 in. (182.9 x 172.7 cm)

Viscosity (Mineral Oil), 1968
PLATE 26
Color Polaroid
4$^{1}/_{4}$ x 3$^{3}/_{8}$ in. (10.4 x 8.6 cm)

Grid (Shaving Cream), 1968
PLATE 27
Color Polaroid
4$^{1}/_{4}$ x 3$^{3}/_{8}$ in. (10.4 x 8.6 cm)

Transparent Plane #1, 1968
PLATE 28
2 color Polaroids
3$^{3}/_{8}$ x 4$^{1}/_{4}$ in. (8.6 x 10.4 cm) each

Transparent Plane #2, 1968
PLATE 29
2 color Polaroids
3$^{3}/_{8}$ x 4$^{1}/_{4}$ in. (8.6 x 10.4 cm) each

Transparent Plane #3, 1968
PLATE 30
Color Polaroid
4$^{1}/_{4}$ x 3$^{3}/_{8}$ in. (10.4 x 8.6 cm)

Out-of-Focus, 1968/1996
PLATE 31 (catalogue image from
alternate source)
Cibachrome
23$^{3}/_{4}$ x 24 in. (60.3 x 61 cm)

Transparent and Opaque, 1968/1998
PLATE 32
12 silver dye bleach prints (Ilfochrome)
16 x 20 in. (40.6 x 50.8 cm) each
Collection Whitney Museum of American Art,
New York

Smear #1, 1968/1998
PLATE 33
Silver dye bleach print (Ilfochrome)
16 x 16 in. (40.6 x 40.6 cm)

Smear #2, 1968/1998
PLATE 34
Silver dye bleach print (Ilfochrome)
16 x 16 in. (40.6 x 40.6 cm)

Smear #3, 1968/1998
PLATE 35
Silver dye bleach print (Ilfochrome)
16 x 16 in. (40.6 x 40.6 cm)

Smear #4, 1968/1998
PLATE 36
Silver dye bleach print (Ilfochrome)
16 x 16 in. (40.6 x 40.6 cm)

Smear #5, 1968/1998
PLATE 37
Silver dye bleach print (Ilfochrome)
16 x 16 in. (40.6 x 40.6 cm)

Smear #6, 1968/1998
PLATE 38...

Smear #6, 1968/1998
Silver dye bleach print (Ilfochrome)
16 x 16 in. (40.6 x 40.6 cm)

Knot, 1968
PLATE 38
Cyanotype
15 x 20 in. (38.1 x 50.8 cm)

Polarized Light (Red/Yellow), 1968
PLATE 39
C-print
10 x 8 in. (25.4 x 20.3 cm)

Polarized Light (Purple/Green), 1968
PLATE 40
C-print
10 x 8 in. (25.4 x 20.3 cm)

Roll, 1968/1998
PLATE 41
8 gelatin silver prints
20 x 24 in. (50.8 x 61 cm) each
Collection Whitney Museum of American Art,
New York

Singer Lab Measurement (#1), 1968
PLATE 42
Gelatin silver print
10 x 8 in. (25.4 x 20.3 cm)

Singer Lab Measurement (#2), 1968
PLATE 43
Gelatin silver print
10 x 8 in. (25.4 x 20.3 cm)

Singer Lab Measurement (#3), 1968
PLATE 44
Gelatin silver print
10 x 8 in. (25.4 x 20.3 cm)

Singer Lab Measurement (#4), 1968
PLATE 45
Gelatin silver print
10 x 8 in. (25.4 x 20.3 cm)

Singer Lab Measurement (#5), 1968
PLATE 46
Gelatin silver print
10 x 8 in. (25.4 x 20.3 cm)

Actual Size (Face), 1968
PLATE 47
Gelatin silver print
22 x 14 1/4 in. (55.9 x 36.2 cm)

Actual Size (Hand), 1968
PLATE 48
Gelatin silver print
22 x 14 1/4 in. (55.9 x 36.2 cm)

**Misunderstandings
(A Theory of Photography)**, 1967–70
PLATE 49
10 photo-offset prints on note cards,
enclosed in a manila envelope
5 x 8 in. (12.7 x 20.3 cm) each

Photography Cannot Record Abstract Ideas,
1969/1998
PLATE 50
Silver dye bleach print (Ilfochrome)
16 x 20 (40.6 x 50.8)

**Projected Plan For 42 Color Photographs
(Tri-Axial Rotation of a Cube)**, 1966
PLATE 51
Pen and ink and colored pencil on graph
paper
17 3/8 x 22 1/8 in. (44.1 x 56.2 cm)

**Three Shots of Each Piece (Study for 36
Photographs and 12 Diagrams)**, 1966
PLATE 52
Pen and ink on graph paper
11 x 8 1/2 in. (27.9 x 21.6 cm)

Block Setups for First Photo Piece, 1966
Pen and ink on graph paper
11 x 8 1/2 in. (27.9 x 21.6 cm)

**Number Series (Study for Magic Squares:
Visually Random)**, 1967
PLATE 53
Pen and ink and graphite on paper
17 3/8 x 22 1/4 in. (44.1 x 56.5 cm)
Collection Jasper Johns

Untitled (Take Photos of All Four AFA Pieces),
1967
PLATE 54
Graphite on lined paper
11 x 8 1/2 in. (27.9 x 21.6 cm)

Plan For Color Photo Piece (Cuts), 1967
PLATE 55
Pen and ink, watercolor, and graphite on
graph paper
13 x 19 in. (33 x 48.3 cm)

Ten Color Coded Isomorphs, 1967
PLATE 56
Pen and ink and colored pencil on
graph paper
17 3/4 x 22 1/2 in. (45.1 x 57.2 cm)

Sixteen Isomorphs (Finch College Installation),
1967
PLATE 57
Colored marker on graph paper
8 1/2 x 11 in. (21.6 x 27.9 cm)

**Constants and Variables: Horizontal
Striations**, 1967
PLATE 58
Pen and ink on graph paper
13 x 19 1/16 in. (33 x 48.4 cm)

**Untitled (Study for Constants and Variables:
Horizontal Striations)**, 1967
Pen and ink on graph paper
11 x 8 1/2 in. (27.9 x 21.6 cm)

**Untitled (Study For Constants and Variables:
Striations [Curved])**, 1967
PLATE 59
Colored marker on lined paper
7 7/8 x 10 3/8 in. (20 x 26.4)

Plan and Set for Photo Piece, 1967
PLATE 60
Pen and ink and graphite on two sheets of
graph paper
24 1/8 x 18 1/8 in. (61.3 x 46 cm)
Collection Cy Twombly

Twelve Sets (Visually Random), 1967
PLATE 61
Photo collage on board
10 5/8 x 10 1/2 in. (27 x 26.7 cm)

**Study For Photo Piece (One Point
Perspective)**, 1967
PLATE 62
Pen and ink on graph paper
11 x 8 1/2 in. (27.9 x 21.6 cm)
Private Collection, Houston

**Untitled (Study for Multiple Perspective
Pieces)**, 1967
PLATE 63
Pen and ink on graph paper
11 x 8 1/2 in. (27.9 x 21.6 cm)

Untitled (Studies for Perspective Overlay),
1967
Pen and ink on paper
11 x 11 in. (27.9 x 27.9 cm)

**Untitled (Study for One Point Perspective:
Four Orientations)**, 1967
PLATE 64
Pen and ink on graph paper
11 x 8 1/2 in. (27.9 x 21.6 cm)

**Six Diagrams for Dispersed Perspectives
(One Point)**, 1967
PLATE 65
Pen and ink and colored pencil on
graph paper
18 x 22 3/8 in. (45.7 x 56.8 cm.)

Dispersed Perspective (One Point), 1967
PLATE 66
Photo collage and graphite on board
17 x 17 in. (43.2 x 43.2 cm)

Untitled (Holes), 1967
PLATE 67
Pen and ink on graph paper
11 x 8 1/2 in. (27.9 x 21.6 cm)

Untitled (Deformations), 1967
PLATE 68
Pen and ink on graph paper
10 x 8 in. (25.4 x 20.3 cm)

Study for Disintegrating Crumples, 1968
PLATE 69
Marker on graph paper
11 x 8 1/2 in. (27.9 x 21.6 cm)

Tracing (Surface Deformation): Recrumpled,
1967–68
PLATE 70
Pen and ink on tracing paper
7 x 4⅝ in. (17.8 x 11.7 cm)

Notes and Procedures: Photograph Series
B/Part 2 (Study for Book), **1969**
PLATE 71
Pen and ink on graph paper, folded
and stapled
8½ x 11 in. (21.6 x 27.9 cm) (each opening)

Untitled (Project Flat Image on Round
Surface), **1968**
PLATE 72
Marker on graph paper
11 x 8½ in. (27.9 x 21.6 cm)

Untitled (Glass/Shadow), **1968**
PLATE 73
Marker on graph paper
11 x 8½ in. (27.9 x 21.6 cm)

Untitled (Wall/Floor/Landscape, St. Martin),
1968
PLATE 74
Ballpoint pen on tracing paper
8½ x 11 in. (21.6 cm x 27.9 cm)

Untitled (First Sketches for Measurement:
Room) (page from The Singer Notes*),* **1968**
PLATE 75
Ballpoint pen on graph paper
11 x 8½ in. (27.9 x 21.6 cm)

New York Windows **(made in collaboration**
with Robert Moskowitz), 1966
FIGS. 31–36
Stills from 16-mm black-and-white film

Selected Bibliography

The following bibliography includes sources that illustrate or make specific reference to Bochner's photographic work.

Armstrong, Phillip. "Mel Bochner." In *As Painting: Division and Displacement*, edited by Phillip Armstrong, Laura Lisbon, and Stephen Melville, 74–79. Cambridge: The MIT Press, 2001.

Battcock, Gregory, ed. *Minimal Art: A Critical Anthology*. New York: E. P. Dutton & Co., Inc., 1968.

Benthall, Jonathan. "Bochner and Photography: Technology and Art 24." *Studio International* 181 (April 1971): 147–48.

Bochner, Mel. "The Serial Attitude." *Artforum* 6 (December 1967): 28–33.

Bois, Yve-Alain, and Rosalind Krauss. *Formless: A User's Guide*. New York: Zone Books, 1997.

Chandler, John. "The Last Word in Graphic Art." *Art International* 12 (November 1968): 25–28.

Field, Richard. "Mel Bochner: Thought Made Visible." In *Mel Bochner: Thought Made Visible 1966–1973*, 15–74, edited by Richard Field. New Haven: Yale University Art Gallery, 1995.

Gablik, Suzi. *Progress in Art*. London: Thames and Hudson, 1976.

Gintz, Claude, Juliette Laffon, and Angeline Scherf, eds. *L'Art conceptuel, une perspective*, exh. cat. Paris: Musée d'Art Moderne de la Ville de Paris, 1989.

Graham, Dan. "Models and Monuments: The Plague of Architecture." *Arts Magazine* 41 (March 1967): 62–63.

_____. "Of Monuments and Dreams." *Art and Artists* I (March 1967): 62–63.

Jacobs, Joseph. *This Is Not a Photograph: Twenty Years of Large Scale Photography 1966–1986*, exh. cat. Sarasota: The John and Mable Ringling Museum of Art, 1987.

LeWitt, Sol. "Paragraphs on Conceptual Art." *Artforum* 5 (Summer 1967): 79–83.

Metzger, Robert. *A Second Talent: Painters and Sculptors Who Are Also Photographers*, exh. cat. Ridgefield, Conn.: Aldrich Museum of Contemporary Art, 1985.

Meyer, James. *Minimalism: Art and Polemics in the Sixties*. New Haven: Yale University Press, 2001.

Newman, Sasha M. "The Photo Pieces." In *Mel Bochner: Thought Made Visible 1966–1973*, 114–19, edited by Richard Field. New Haven: Yale University Art Gallery, 1995.

Penders, Anne-Françoise. "Photo-Texte-Abyme." *Pratiques* 7 (Autumn 1999): 72–88.

Perreault, John. "Union Made: Report on a Phenomenon." *Arts Magazine* 41 (March 1967): 26–31.

Pincus-Witten, Robert. "Mel Bochner: The Constant as Variable." *Artforum* 11 (December 1972): 28–34.

Richardson, Brenda. *Mel Bochner: Number and Shape*, exh. cat. Baltimore: The Baltimore Museum of Art, 1976.

Rorimer, Anne. *New Art in the 60s and 70s: Redefining Reality*. London: Thames and Hudson, 2001.

Sloane, Patricia. "Scale Models, Drawings." *Arts Magazine* 41 (February 1967): 57.

Todolí, Vincente, ed. *Circa 1968*, exh. cat. Porto, Portugal: Museu de Arte Contemporânea de Serralves, 1999.

Valabreque, Frederic. "Mel Bochner, From Idea to Experience." *Arte Factum* 5 (June–August 1988): 14–17.

Vanel, Hevrvé. "Notes sur Mel Bochner." *Pratiques* 9 (Autumn 2000): 18–34.

Wilmes, Ulrich. "36 Photographs and 12 Diagrams." In *Das Gedächtnis öffnet seine Tore, Die Kunst der Gegenwart im Lenbachhaus München*, edited by Helmut Friedel and Ulrich Wilmes, 34–35. Ostfildern-Ruit: Hatje Cantz Verlag, 1999.

Selected Exhibition History

The following is a list of group and solo exhibitions that have included examples of Bochner's photographic work.

1967

SCALE MODELS AND DRAWINGS
New York: Dwan Gallery, January

MONUMENTS, TOMBSTONES, AND TROPHIES
New York: Museum of Contemporary Crafts, 17 March–14 May

ART IN SERIES
New York: Finch College Museum of Art, 21 November–6 January 1968

1968

GROUP EXHIBITION
New York: Bykert Gallery, Spring

REJECTIVE ART
New York: Organized by Lucy Lippard for the American Federation of Arts; traveled

1970

ARTISTS AND PHOTOGRAPHS
New York: Multiples Gallery, April

1976

PHOTONOTATIONS
New York: Rosa Esman Gallery

MEL BOCHNER: NUMBER AND SHAPE
Baltimore: Baltimore Museum of Art, 5 October–28 November

1977

PHOTONOTATIONS II
New York: Rosa Esman Gallery

1985

A SECOND TALENT: PAINTERS AND SCULPTORS WHO ARE ALSO PHOTOGRAPHERS
Ridgefield Connecticut: Aldrich Museum of Contemporary Art

1987

THIS IS NOT A PHOTOGRAPH: TWENTY YEARS OF LARGE SCALE PHOTOGRAPHY
Sarasota, Florida: The John and Mable Ringling Museum of Art, 7 March–31 May

1988

THE TURNING POINT: ART AND POLITICS IN 1968
Cleveland: Cleveland Center for Contemporary Art, 9 September–26 October; The Bronx: Lehman College Gallery, 10 November–14 January 1989

1989

L'ART CONCEPTUEL, UNE PERSPECTIVE
Paris: Musée d'Art Moderne de la Ville de Paris, 22 November–18 February 1990; traveled to La Fundación Caja de Pensiones, Madrid

1991

MEL BOCHNER: PHOTO PIECES 1966–1967
New York: David Nolan Gallery, 8–31 March

MOTION AND DOCUMENT—SEQUENCE AND TIME: EADWEARD MUYBRIDGE AND CONTEMPORARY AMERICAN PHOTOGRAPHY
Washington, D.C.: National Museum of American Art, 28 June–8 September; Andover, Mass.: Addison Gallery of American Art, 18 October–15 December; traveled throughout 1993

1995

MEL BOCHNER: THOUGHT MADE VISIBLE 1966–1973
New Haven: Yale University Art Gallery, 12 October–31 December; Brussels: La Société des Expositions du Palais des Beaux-Arts, 1 March–12 May; Munich: Städtische Galerie im Lenbachhaus, 26 June–8 September

1996

L'INFORME: MODE D'EMPLOI
Paris: Centre Georges Pompidou, 22 May–26 August

MEL BOCHNER: WORKS 1966–1996
New York: Sonnabend Gallery, 2–30 November

1997
MEL BOCHNER: PROJETS
À L'ÉTUDE/1966–1996
Geneva: Cabinet des Estampes du
Musée d'Art et d'Histoire,
27 February–3 April

1999
MEL BOCHNER: COUNTING AND
MEASURING PIECES 1966–1998.
Yokosuka, Japan: Akira Ikeda Gallery,
1 February–30 June

CIRCA 1968
Porto, Portugal: Museu de Arte
Contemporânea de Serralves,
6 June–29 August

2000
MEL BOCHNER: PAINTINGS, INSTALLATIONS,
DRAWINGS, PHOTOGRAPHS 1966–1999
Beverly Hills: Grant Selwyn Fine Art,
27 January–4 March

IN PROCESS: PHOTOGRAPHS FROM
THE LATE 1960s AND 1970s
New York: Curt Marcus Gallery,
20 October–25 November

2001
ART EXPRESS—ART MINIMAL ET
CONCEPTUAL AMERICAIN
Geneva: Cabinet des Estampes du
Musée d'Art et d'Histoire at
Le Musée d'Art Modern et Contemporain,
31 May–30 September

AS PAINTING: DIVISION AND DISPLACEMENT
Columbus, Ohio: Wexner Center for the Arts,
12 May–12 August

Acknowledgments

This exhibition and catalogue would not have been possible without the unstinting support of Jim Cuno and Yve-Alain Bois, both of whom encouraged me to undertake this project while still a senior at Harvard College. As director of the Harvard University Art Museums, Jim arranged a fellowship, funded by the Fifth Floor Foundation, to provide an invaluable year of research in Bochner's New York studio and archive. Since the exhibition's inception, Jim has accommodated every imaginable request, whether for more time, space, or funding—not to mention advice. Yve-Alain, too, deserves my profound appreciation for providing tireless help on all stages of this project, from suggesting the first studio visit to the last catalogue revision. For more than four years, he has been a constant source of invaluable expertise, honest appraisals, and heartening confidence.

The curators and staff of the Harvard University Art Museums have generously assisted me throughout the exhibition's preparation, and I am thankful for both their exceptionally high standards and their even more exceptional patience. Rachel Vargas, Anne Driesse, and Danielle Hanrahan have masterfully handled the shipping arrangements, conservation, and installation design, respectively. Richard Benefield and Stephanie Schilling, along with Jennifer Roberts and Marsy Sumner, attended to the details of the exhibition's finances. Rebecca Wright, aided by Evelyn Pan Bavier and Susannah Hutchison, helped keep track of vast correspondence and crucial fundraising. Debi Kao shared her detailed knowledge of photography, while Harry Cooper offered important early enthusiasm for the exhibition and deft suggestions for fine-tuning the final draft of the essay. Most importantly, Linda Norden devoted endless hours to every aspect of this project; I am sincerely thankful for the true selflessness with which she always offered her help and thoughtful conversation.

In the preparation of this catalogue, Evelyn Rosenthal has acted as an indispensable source of editorial advice and as a liaison to Yale University Press. At Yale, Patricia Fidler oversaw the editing of this book with great intelligence and tact, while Daphne Geismar attended to its design, Jeff Schier handled its final editing, and Mary Mayer managed its production. I am particularly grateful to Elisabeth Sussman for her fine contribution to the catalogue and for first sparking my interest in Bochner's photographic work.

Numerous other individuals and institutions provided valuable assistance and support during the course of this project. Crucial funding for the exhibition was generously provided by Suzanne F. Cohen, Deborah and Martin Hale, Keith and Katherine Sachs, George David, Constance R. Caplan, Arthur M.

Cohen, Mr. and Mrs. D. Ronald Daniel, Barbara Krakow Gallery, and the John M. Rosenfield Teaching Exhibition Fund. The exhibition was also greatly enriched by the loan of works from the Städtische Galerie im Lenbachhaus, the Whitney Museum of American Art, Suzanne F. Cohen, Jasper Johns, David Nolan and Carol Eckman, Cy Twombly, and one anonymous lender. Antonio Homem and the staff of the Sonnabend Gallery made Bochner's work available for my research and cooperated with the loans and shipping of objects for the exhibition. Henri Zerner, director of Graduate Studies, and the entire faculty of Harvard's Department of History of Art and Architecture enabled me to work on this exhibition and catalogue while pursuing my Ph.D. Liz Ross and Lizbeth Marano made useful editorial suggestions, and Francesca and Piera Bochner kindly endured my ubiquitous presence in their home and my demands on their father's time. Christine Mehring, Matt Saunders, and Alexis Sornin have immensely enriched my thinking and writing, as well as my life. In addition, Gary and Leslie Null and Michael and Alaine Rothkopf have all offered tremendous help and support, as only they can.

Finally, my greatest gratitude goes to Mel Bochner. On my first visit to his studio, we embarked on a rich and ambling four-hour dialogue, which ultimately spanned three years, and will surely stretch further still. Throughout that time he has helped me to understand the way an artist thinks and works, and he has graciously accepted my questions and challenges. Always, he has unsparingly shared his art, his insight, his wit, and his friendship; I am thankful for these gifts, and many more.